炫繪

序

繼 2011 出版的第一本首飾設計書《雅繪》後，今年再接
再厲，將 2012 年至 2019 年的所有設計繪集成第二本設
計書《炫繪》。

在 2011 年之後，我人生出現了轉折點，由開心快活人轉
入沒有隱私的世界，受盡精神折磨。

在沒有自由的日子中，為自己創造出開心的源泉，設計
自己喜愛的首飾，苦中作樂。

當知道自己的設計被有心人暗中以神經網絡收集為製作
人工智能時，在不忿與無奈的情況下，將自己的設計集
書出版，以宣示版權所在。

PREFACE

Following the first jewellery design book *Stroke of Grace* which published in 2011. In the year of 2024, I have continued my inspiration and concept, and integrated all my jewellery design pattens from 2012 to 2019 into the second design book of *Dazzling of Grace*.

After 2011, there was a turning point in my life. I was from a happy person turned to a dark world which without privacy.

In the such critical moment, I would like to create a source of happiness for myself, design my favourite jewellery for my own to less my pain and balance my mental health.

When I found out that my designs were secretly collected by neural networks to create artificial intelligence, I felt helpless, so planning to published my book of all my designs to declare my copyright.

目錄

Brooch 襟針

舞出自我 Dance to Confidence	12	
自由鳥 Freedom Bird	13	
分枝同心 Branches in Same Heart	14	
龍吐珠 Pearl from Dragon	15	
共贏 Win-Win	16	
禾稈珍珠 Pearl on the Straws	17	
弧與邊 Curve and Line	18	
矛與盾 Spear and Shield	19	
繽紛 Colourful	20	
煙花 Firework Display	21	
醫道 Art of Healing	22	
萬壽菊 Marigold	23	
綠身蝴蝶 Jade Butterfly	24	
豐收 Rich Harvest	25	
淑女 Dancer	26	
溢滿天飛 Swirled Wildly	27	
風雨中的蝴蝶 Hurricane Butterfly	28	
勝利 Victory	29	
彩蝶 Colourful Butterfly	30	
採花蝶 Butterfly Flower	31	
力爭上游 High Ambitions	32	

聖誕福音 Christmas Brooch	33
雨後玫瑰 Rose after Rain	34
花扇 Sparkle Rose	35
花樣年華 Golden Year	36
正與邪 Bright and Dark	37
龍馬精神 Dragon Horse Spirit	38
福盈滿框 Blissful Frame	39
圓滿 Perfect Round	40
蝴蝶效應 Butterfly Effect	41
里拉琴 Lyre	42
蓮華生輝 Friends Grace	43
幼教 Math Tool	44
大號 Tuba	45
豎琴 Harp	46
佛像 Buddha	47
畫中蝶 Art of Butterfly	48
蝴蝶展翅 Butterfly in Fly	49
上帝之眼 Eyes of God	50
羽毛 Feather	51
眼部跟蹤 Eyes Stalking	52
腦禁錮 Mind Control	53
小心眼 Beware of Eyes	54

操控手 Controller 55

如影隨形 Shadow 56

靈魂伴侶 Soul Mate 57

蜻蜓 Dragonfly 58

蘭花 Orchid 59

珍珠盾 Art of Pearl 60

肺腑之言 The Truth 61

香水蘭花 Orchid Perfum 62

線蝴蝶 Wires of Butterfly 63

魔鬼蝴蝶 Shadowy Butterfly 64

藍星蝴蝶 Blue Star Butterfly 65

鳳凰儀 Phoenix 66

鳳舞 Dancing Phoenix 67

鳳之姿 Amazing Phoenix 68

白玉髓蘭花 White Orchid 69

獻花 Floral 70

洋紫荊 Hong Kong Orchid 71

步步高升 Promotion 72

波浪蝶 Blue Morpho 73

觀星者 Moon Traveller 74

Clip 呔夾

幾何圖案 Geometric Patterns 76

圓點 Center Point 77

兩線的匯合 Twists 78

Cuff 手鐲

馬賽克手鐲 Mosaic Cuff 80

剪彩用禮品 Ribbon Cutting Gift 81

圈中圈 Throw-off Circle 82

白蘭花手鐲 White Champace Cuff 83

白蝴蝶手鐲 White Butterfly Cuff 84

心連心 Heart to Heart 85

滴水成金 Drops to Gold 86

Earring 耳環

聚少成多 Accumulation 88

藍玉髓耳環 Blue Chalcedony Earring 89

粉紅鑽耳環 Fancy Diamond Earring 90

黃玉髓耳環 Yellow Chalcedony Earring 91

齊齊整整 Good Order 92

配對 Mix and Match 93

相輝映 Reflection 94

對稱 Symmetry 95

開枝散葉 Flourishing 96

袋袋平安 Peace 97

唇齒相依 Happiness 98

艷紅 Ruddy 99

好出色 Twist to Colour 100

白蘭花香 White Champace 101

金銀花卉 Golden Flowers 102

綠仙子 Jade Fairy 103

藍仙子 Blue Fairy 104

相聚 Gathering 105

同心扣 Heart Chain 106

星球 Small Planet 107

三重奏 Trio 108

水濂 Curtain 109

耀舞揚威 Big Show 110

環環相扣 Locking 111

陰陽扇 Match Fan 112

塔裙 Flaming Skirt 113

光彩 Sparkle 114

色色相關 Colourful 115

心花怒放 Elated 116

爭艷 Competition 117

花開四季 Season Flowers 118

圓滿配合 Perfect Match 119

譜出樂曲 Melody 120

中規中矩 Balance 121

Necklace 頸鏈

四海匯聚 Linking to World 124

藍玉髓頸圈 Blue Chrysocolla Collar 125

願望成真 Wish Comes True 126

領先同群 Number One 127

三色扣 Colourful Chain 128

順利圓滿 Successful 129

生生不息 Infinity 130

愛心 Kindness 131

川流不息 Endless 132

生氣洋溢 Brilliant 133

七彩世界 Colourful World 134

叢林之光 Jungle Light 135

百川匯聚 Collection 136

歡樂滿堂 Happiness Generation 137

奪冠 Winner 138

水之源 Water of Life 139

紅寶石頸圈 Ruby Collar 140

袋袋相傳 Luxury Bags 141

萬子千孫 Fruitfulness 142

玉提子頸鏈 Jade Grape Necklace 143

聯盟 Alliance 144

美鑽匯聚 Art of Diamond 145

掛念 Solicitude 146

金睛火眼 Concentration 147

串串寶 Precious Stones 148

擁護 Champion 149

領先者 Go Ahead 150

滴水成金 Drops to Gold 151

花樣年華 Teenage 152

馬蹄蘭頸鏈 Lily Necklace 153

玉蘭花頸鏈 White Champace Necklace 154

鑽石花 Diamond Flora 155

愛心傳承 Baton of Love 156

點滴在心中 Droplets 157

金玉良緣 Gold and Jade 158

白玉無瑕 Impeccable Integrity 159

生生不息 Circle of Life 160

花卉頸鏈 Floral Necklace 161

瑰寶 Treasure 162

脫俗頸鏈 Ethereal Necklace 163

幾何圖形 Geometric Patterns 164

點綴其中 Art of Decoration 165

四季 Four Seasons 166

層次分明 Layers 167

百寶袋 Treasure Bag 168

點綴平衡 Art of Balance 169

古器今用 Vintage 170

紅碧璽四方頸鏈 Tourmaline Square Necklace 171

點點星輝 Sparkle Diamond 172

真情所至，金石為開 True Love 173

金葉 Gold Leaf 174

明燈 Guiding Star 175

古式古香 Vintage Style 176

Pendant & Brooch (use in both)
吊墜和襟針兩用

魚躍龍門 Dive Forward 178

皮影花 Shadow Flower 179

展翅 Fly Up	180	月下之花 Flowers under Moon	202
高飛 Soar	181	爭取自由 Break Out	203
含苞待放 Budding	182	彩色玉扣 Colourful Jade	204
金銀線頸鏈 Metical Yarn Necklace	183	幾何藝術 Art of Triangles	205
倒影 Art of Reflection	184	四方八面 Cubics	206
亂中有序 Order in Chaos	185	日月星辰 Sun and Moon	207
穿越時空 Voyage	186	炫光蝶 Glare Butterfly	208
豆之美 Art of Bean	187	順與逆 Time and Tide	209
金錢以外 In and Out	188	黑白蝴蝶 Black and White Butterfly	210
三維空間 3D Oval	189	四方蝴蝶 Square Butterfly	211
翩舞 3D Waltzing	190	圓滿配搭 Circles	212
花朵綻放 Blossoming	191	幾何花開 Circle and Square	213
金珠點綴 Decoration of Pearl	192	追光者 Light Chaser	214
閃爍金珠 Vague Pearl	193	藍寶石吊墜 Sapphire Pendant	215
光芒四射 Brightening	194	相對拼貼 Mirror Collage	216
隨意 Arbitrary	195	黃玉吊墜 Yellow Chalcedony	217
三眼同盟 Three Eyes	196	精打細算 Golden Abacus	218
同心協力 Solidarity	197	金色馬蹄蘭 Golden Lily	219
天使 Angel	198	畫中雨 Art of Diamond	220
花花世界 Flowers World	199	寶石藝術 Art of Gems	221
花藝 Flower Design	200	菱形設計 Art of Rhombus	222
霧裏花 Dazzling Flower	201	中心點 Central Diamond	223

擦出火花 Flaming 224

一點綠 Green Dot 225

如魚得水 Vivid Fish 226

栩栩如生 Golden Fish 227

魚美人 Dancing Fish 228

瑰麗 Display of Colours 229

Ring 戒指

外方內圓 Ring in the Box 232

雙珠戒指 Double Pearls 233

珍珠戒指 Pearl Ring 234

雙色鑽石戒指 Diamond Ring 235

藍線戒指 Packing Ring 236

花樣戒指 Flowers Ring 237

花架 Jardiniere 238

軟硬兼備 Elasticity 239

眼中世界 In Your Eyes 240

藍天蝶雲 Butterfly in Sky 241

彩半球 Colourful Hemisphere 242

掌上明珠 Pearl on the Palm 243

指上寶座 Ring of Throne 244

USB 記憶體

來日方長 Time to Memory 246

金手指 Golden Finger 247

拼圖 Puzzle USB 248

妙筆生花 USB with Touch Screen Pen 249

權力 Power 250

拍檔 Partner 251

金鎖匙 Golden Key 252

Set 套裝

不規則圖案 Random Pattern 254

襟 針

BROOCH

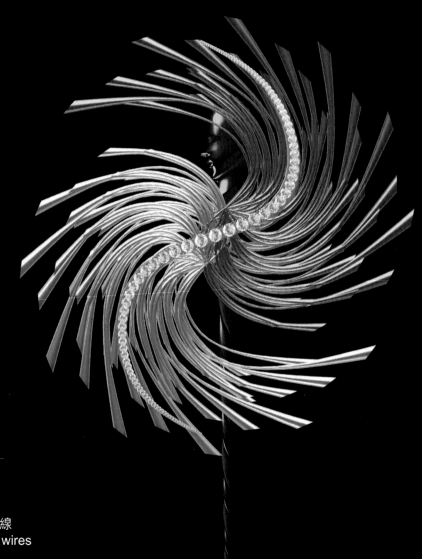

舞 出 自 我
Dance to Confidence

白金，黃金，安力士，紫色銀線
Platinum, Gold, Onyx, Purple wires

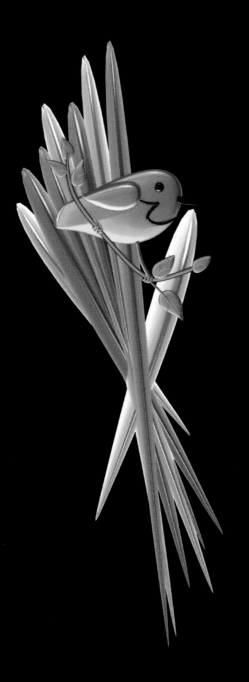

自 由 鳥
Freedom Bird

白金，黃金，玫瑰金，黃藍綠鋁合金
Platinum, Gold, Colour gold, Colour aluminum

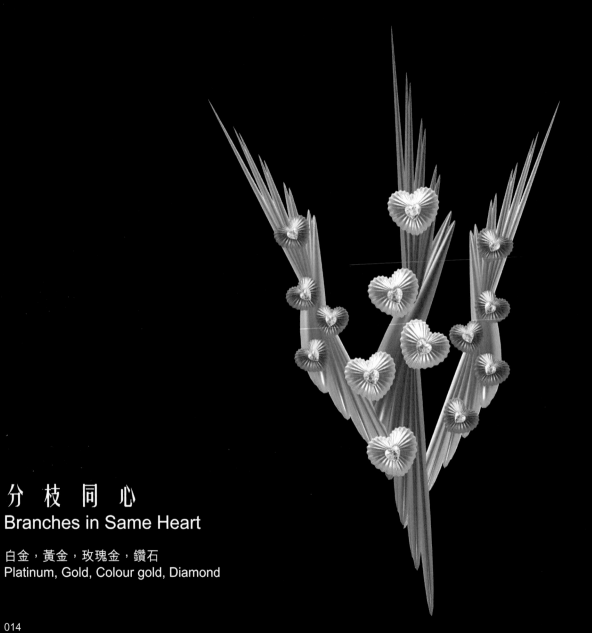

分 枝 同 心
Branches in Same Heart

白金，黃金，玫瑰金，鑽石
Platinum, Gold, Colour gold, Diamond

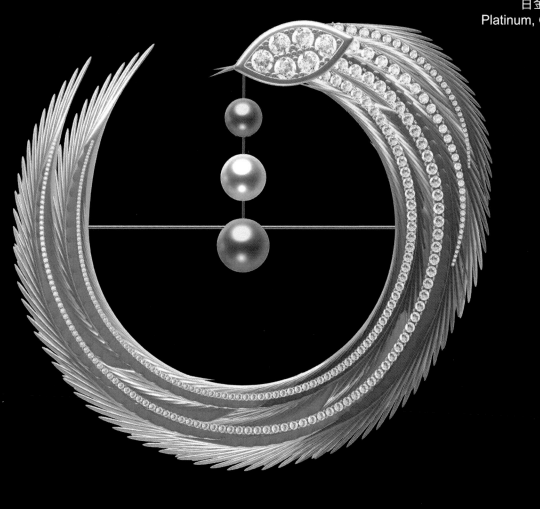

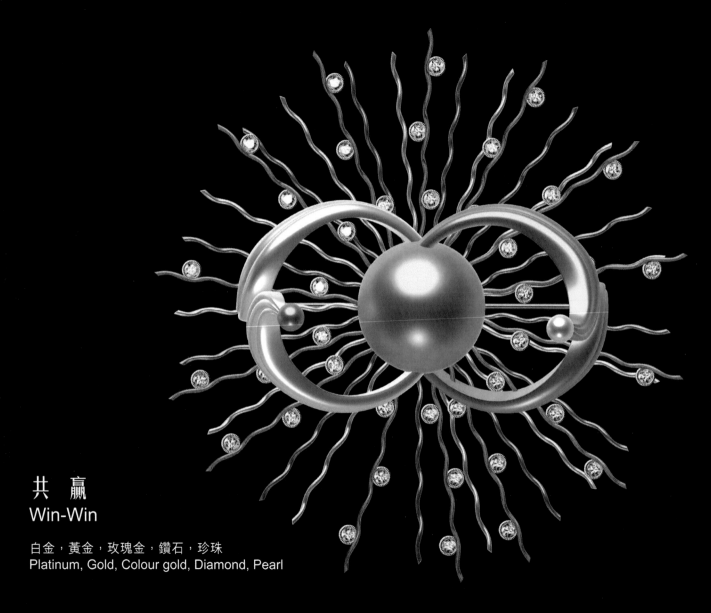

共　贏
Win-Win

白金，黃金，玫瑰金，鑽石，珍珠
Platinum, Gold, Colour gold, Diamond, Pearl

禾稈珍珠
Pearl on the Straws

黃金，玫瑰金，珍珠
Gold, Colour gold, Pearl

弧 與 邊
Curve and Line

白金，黃金，鑽石
Platinum, Gold, Diamond

矛 與 盾
Spear and Shield

黃金，鑽石，珍珠，顏色玉髓
Gold, Diamond, Pearl, Colour chalcedony

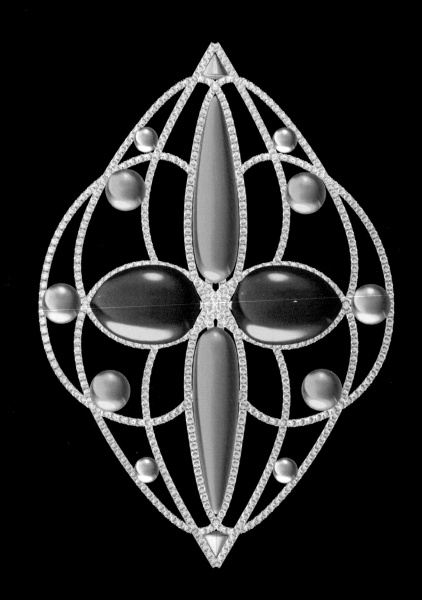

繽 紛
Colourful

白金，顏色玉髓
Platinum, Colour chalcedony

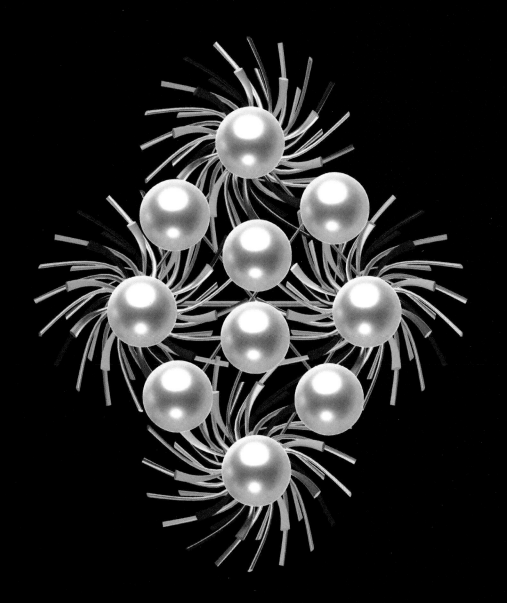

煙 花
Firework Display

珍珠，顏色銀線
Pearl, Colour silver wires

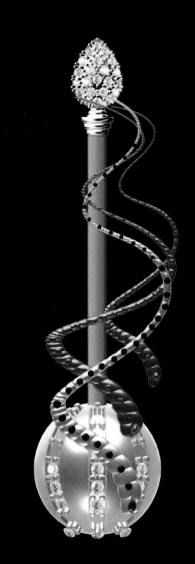

醫 道
Art of Healing

白金，玫瑰金，鑽石，珍珠，
玉石，安力士，紅寶石
Platinum, Colour gold, Diamond,
Pearl, Jade, Onyx, Ruby

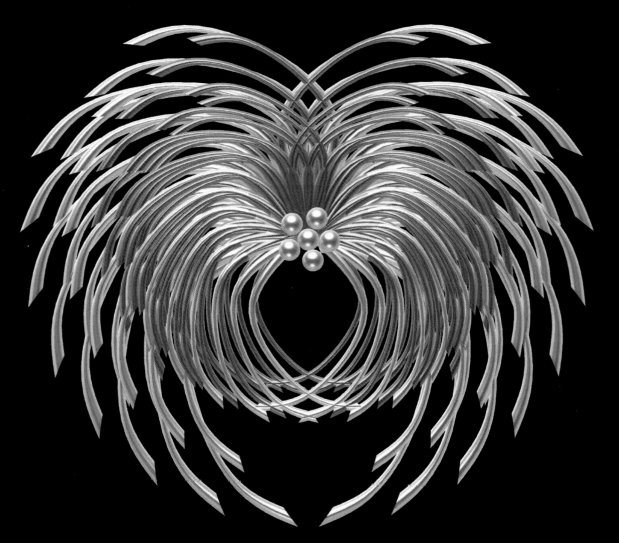

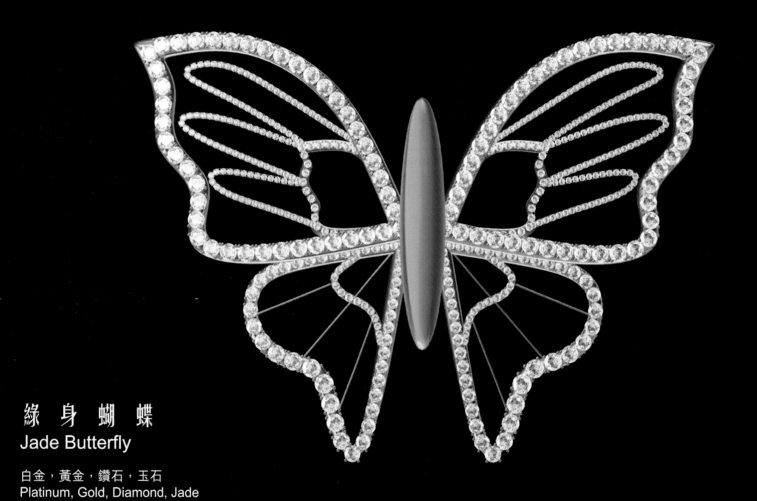

綠身蝴蝶
Jade Butterfly

白金，黃金，鑽石，玉石
Platinum, Gold, Diamond, Jade

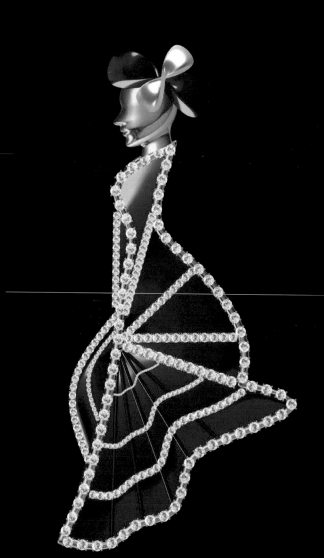

淑 女
Dancer

白金，黃金，鑽石，藍色琺瑯
Platinum, Gold, Diamond, Blue enamel

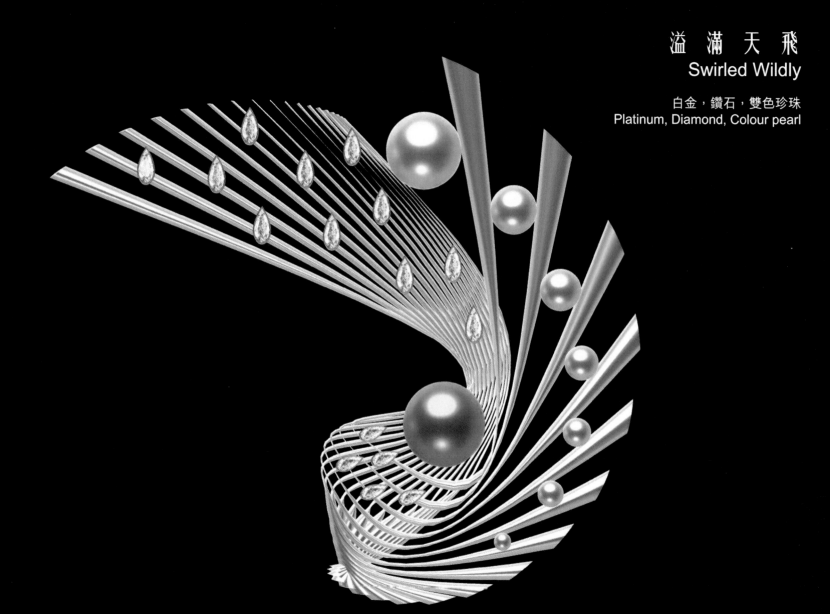

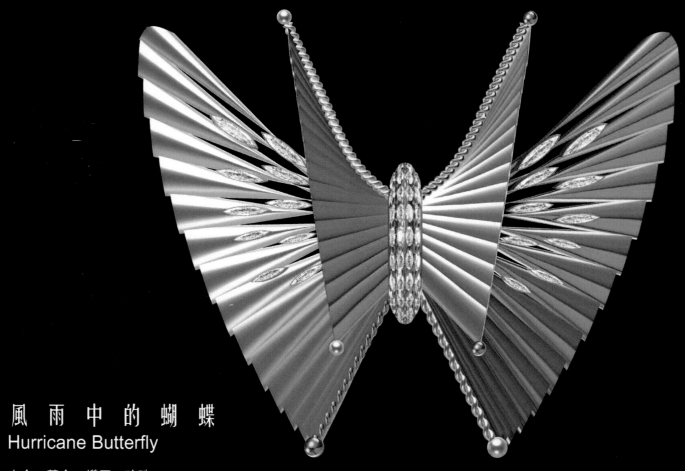

風 雨 中 的 蝴 蝶
Hurricane Butterfly

白金，黃金，鑽石，珍珠
Platinum, Gold, Diamond, Pearl

勝 利
Victory

白金，黃金，珍珠，藍寶石，七色銀線
Platinum, Gold, Pearl, Sapphire,
Colour silver wires

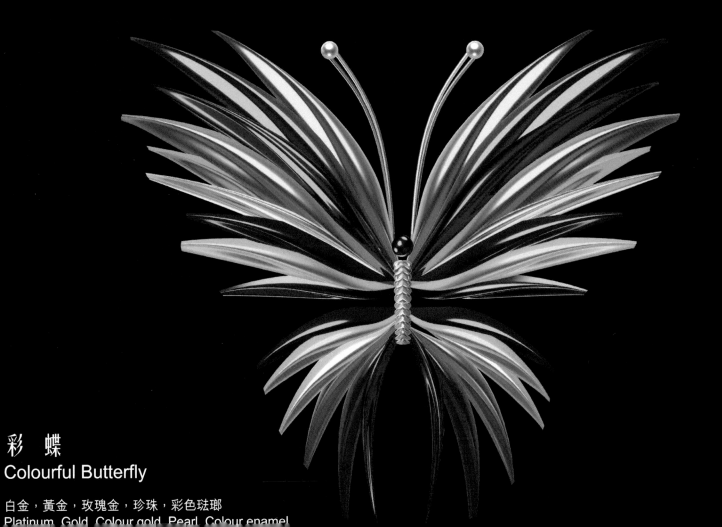

彩 蝶
Colourful Butterfly

白金，黃金，玫瑰金，珍珠，彩色琺瑯
Platinum, Gold, Colour gold, Pearl, Colour enamel

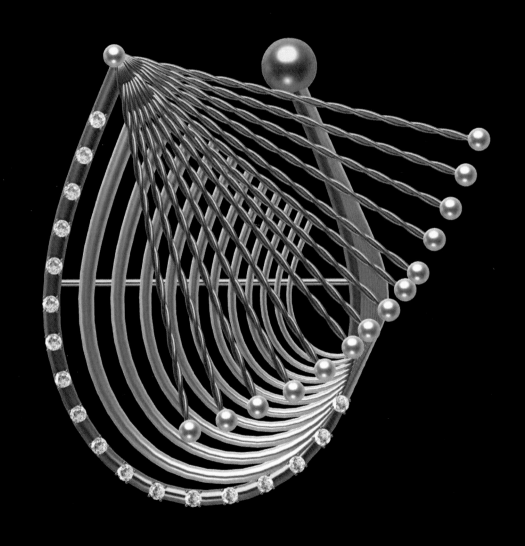

力 爭 上 游
High Ambitions

白金，黃金，鑽石和珍珠
Platinum, Gold, Diamond, Pearl

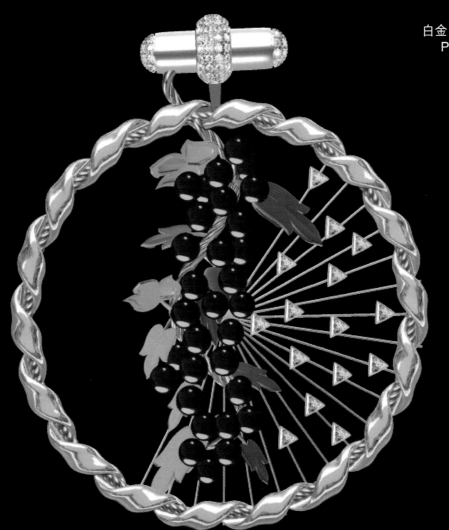

花 樣 年 華
Golden Year

白金，黃金，鑽石，珍珠
Platinum, Gold, Diamond, Pearl

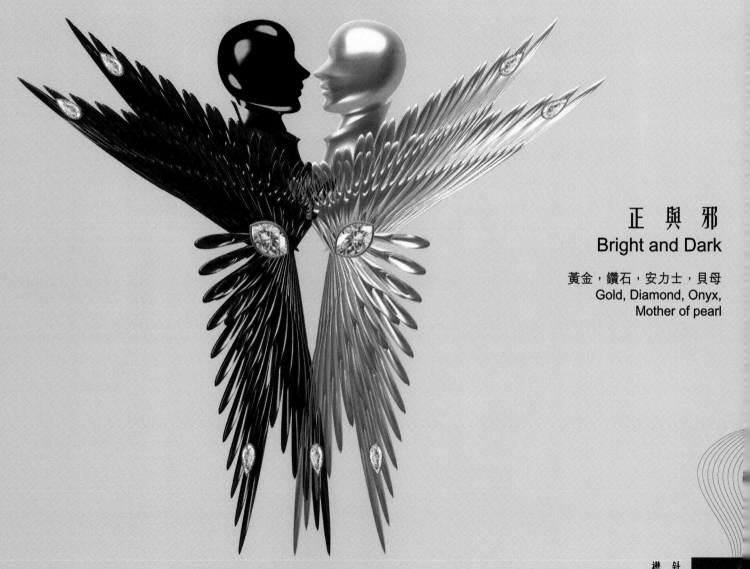

正 與 邪
Bright and Dark

黃金，鑽石，安力士，貝母
Gold, Diamond, Onyx,
Mother of pearl

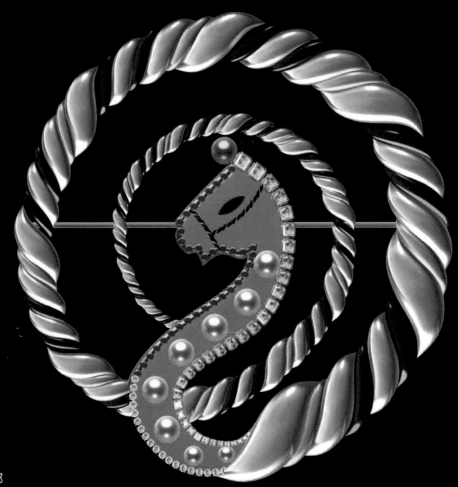

龍馬精神
Dragon Horse Spirit

黃金，鑽石，珍珠，彩色琺瑯
Gold, Diamond, Pearl, Colour enamel

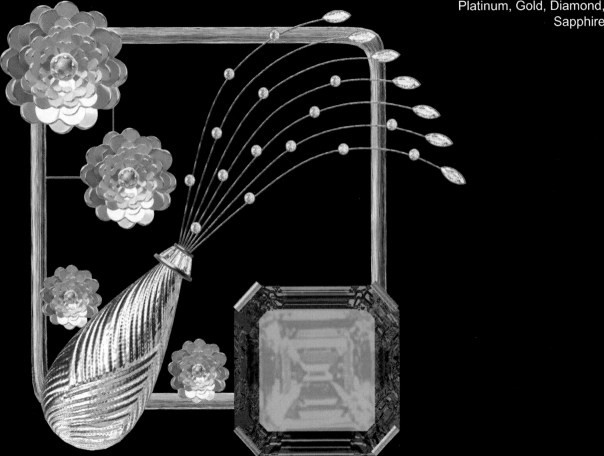

Platinum, Gold, Diamond,
Sapphire

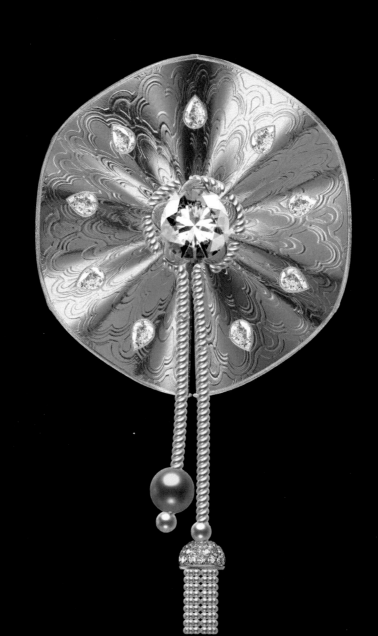

圓　滿
Perfect Round

白金，黃金，鑽石，珍珠
Platinum, Gold, Diamond, Pearl

黃金，鑽石
Gold, Diamond

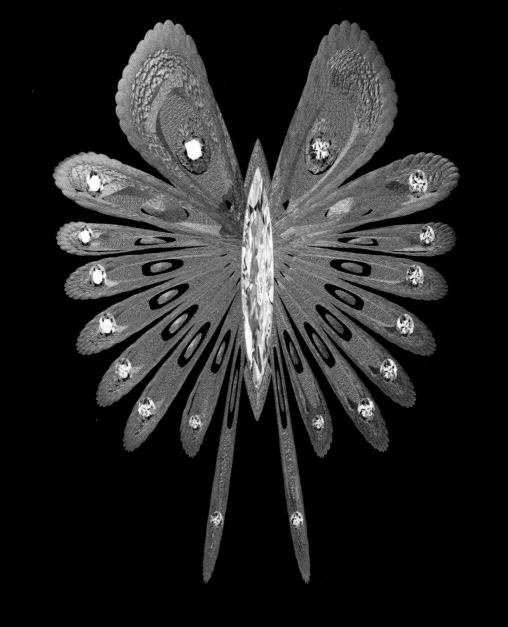

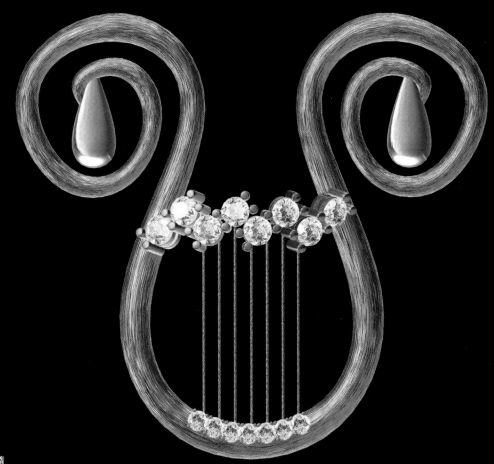

里 拉 琴
Lyre

白金，黃金，鑽石，白玉髓
Platinum, Gold, Diamond,
White chalcedony

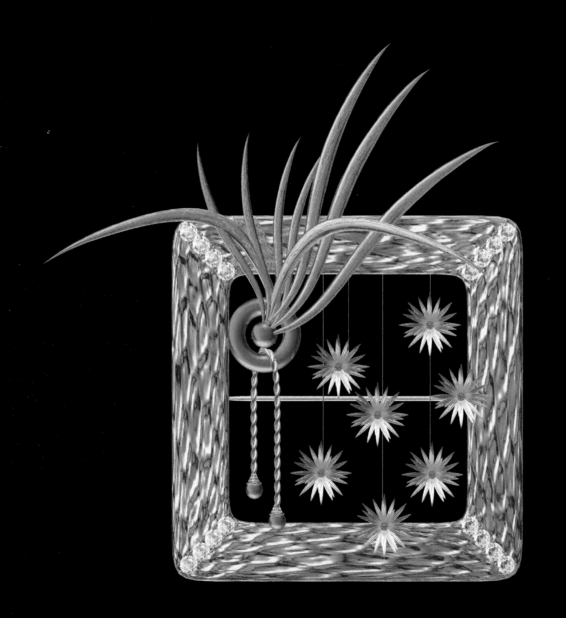

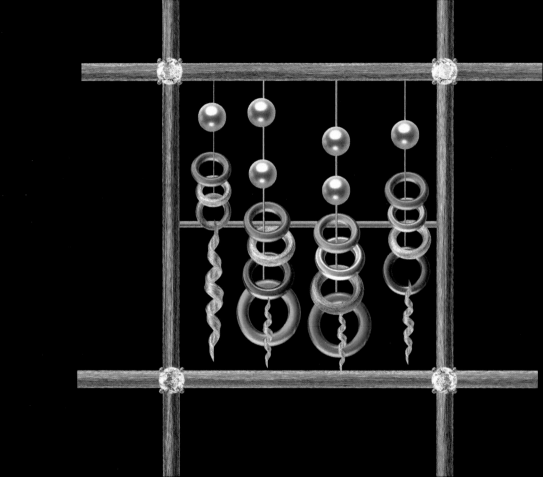

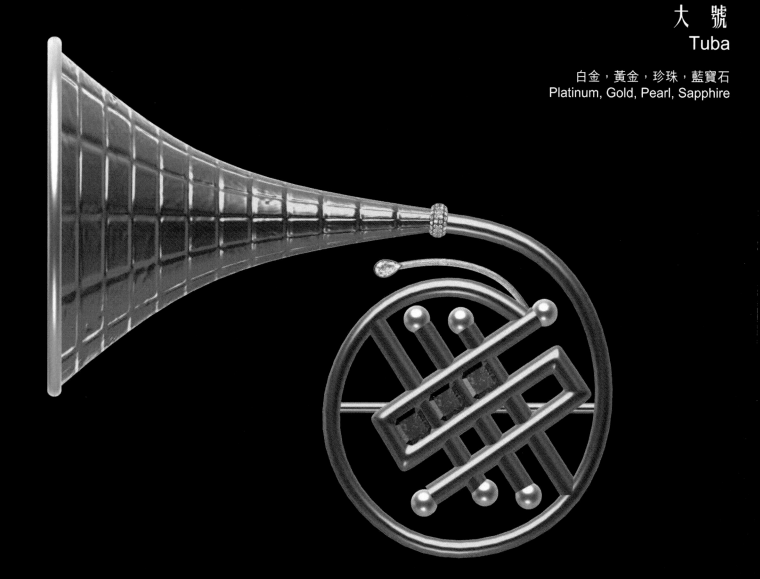

白金，黃金，珍珠，藍寶石
Platinum, Gold, Pearl, Sapphire

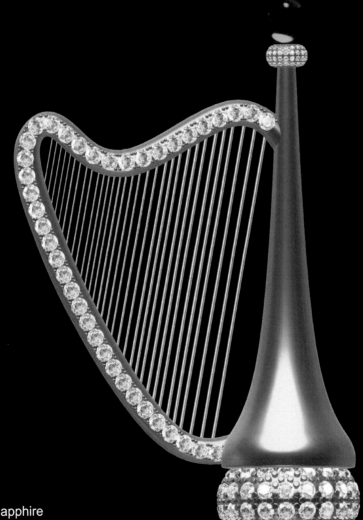

豎琴
Harp

白金，黃金，鑽石，藍寶石
Platinum, Gold, Diamond, Sapphire

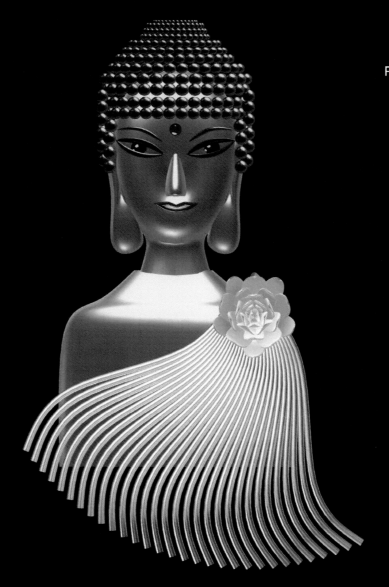

佛 像
Buddha

白金，黃金，黑珍珠，紅寶石
Platinum, Gold, Black pearl, Ruby

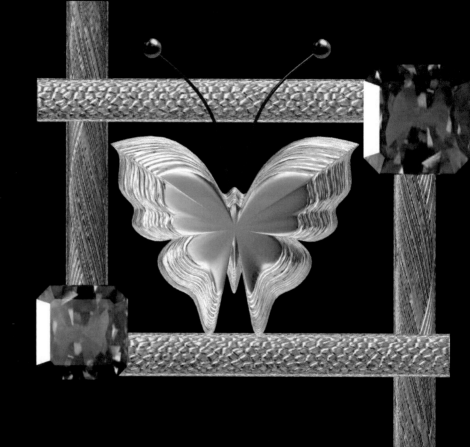

畫 中 蝶
Art of Butterfly

白金，黃金，藍寶石，黑珍珠，紅色銀線

白金，黃金，鑽石，黑白珍珠
Platinum, Gold, Diamond,
Black and white pearl

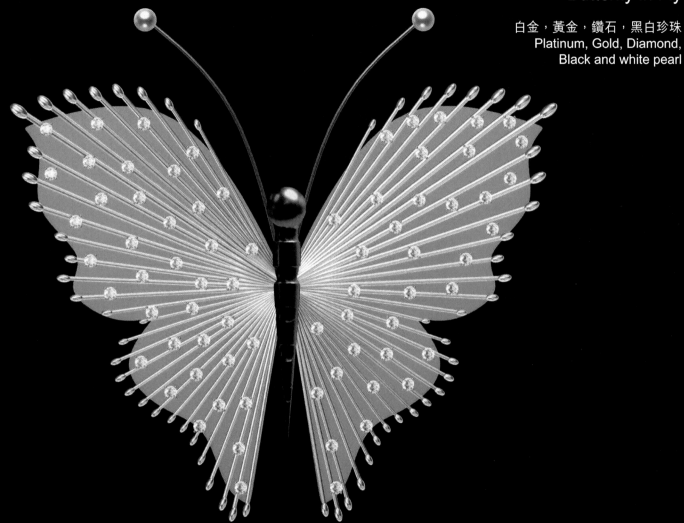

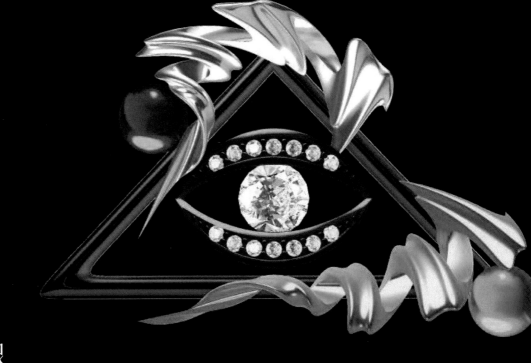

上 帝 之 眼
Eyes of God

白金，黃金，鑽石，紫玉髓，翠玉髓，紅黑鋁合金
Platinum, Gold, Diamond, Purple and green chalcedony,

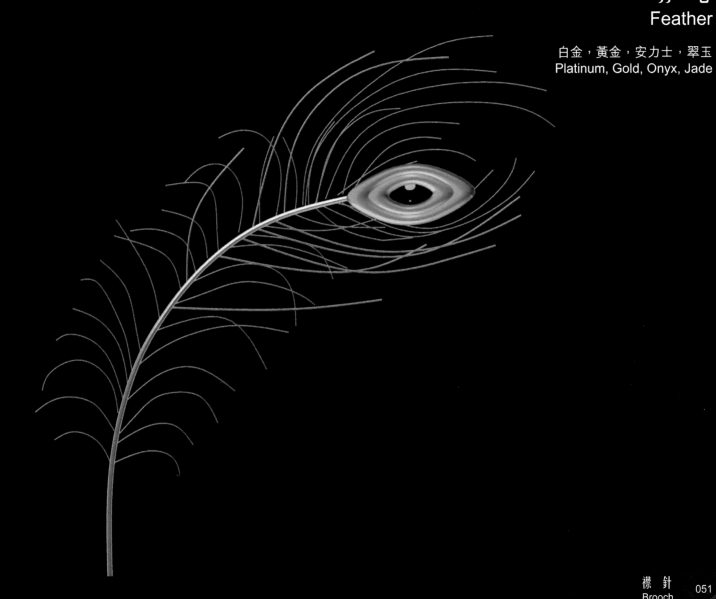

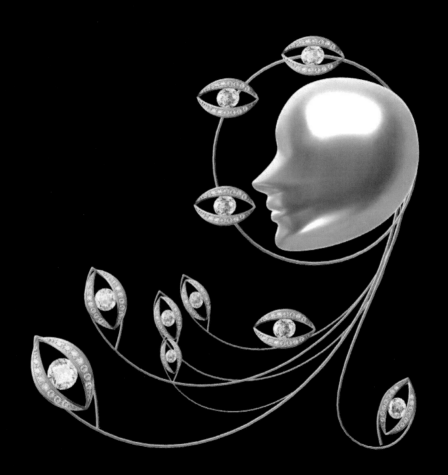

眼 部 跟 蹤
Eyes Stalking

黃金，鑽石，貝母
Gold, Diamond, Mother of pearl

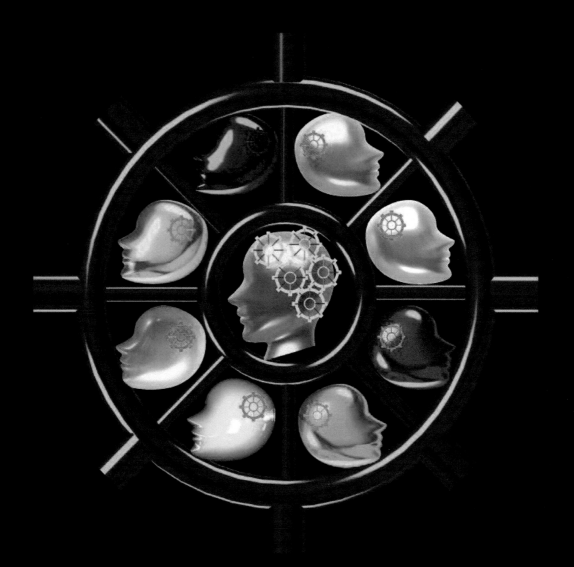

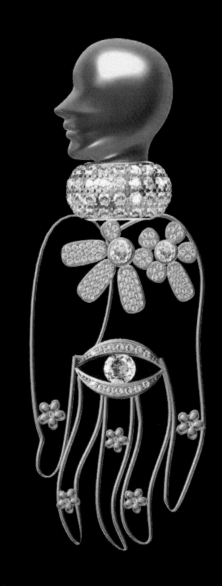

小 心 眼
Beware of Eyes

黃金，鑽石，鋁合金
Gold, Diamond, Aluminum

054

如 影 隨 形
Shadow

鑽石，鋁合金
Diamond, Aluminum

鑽石，鋁合金
Diamond, Aluminum

蜻 蜓
Dragonfly

白金，鑽石，紫玉髓，綠玉髓，
黃玉髓，珍珠，鋁合金
Platinum, Diamond, Colour chalcedony,
Pearl, Aluminum

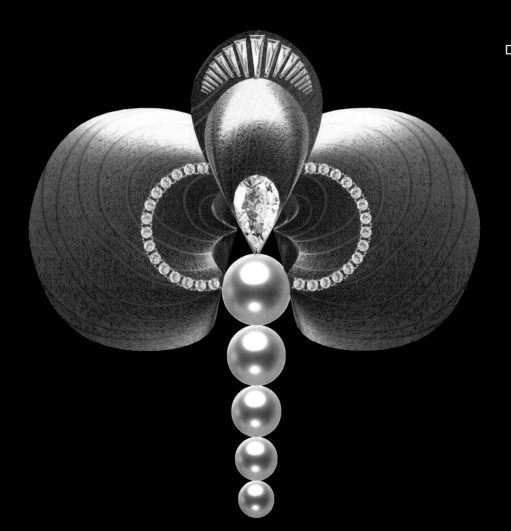

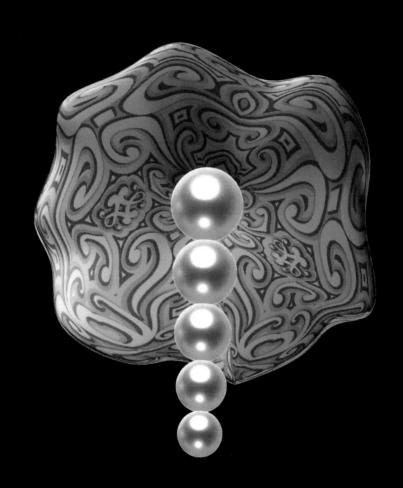

珍 珠 盾
Art of Pearl

黃金，珍珠
Gold, Pearl

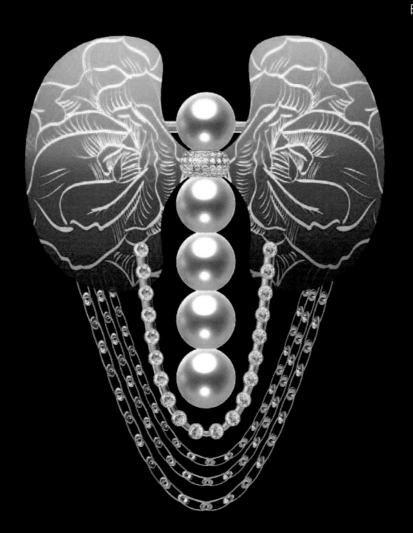

肺 腑 之 言
The Truth

白金，黃金，鑽石，珍珠，鋁合金
Platinum, Gold, Diamond,
Pearl, Aluminum

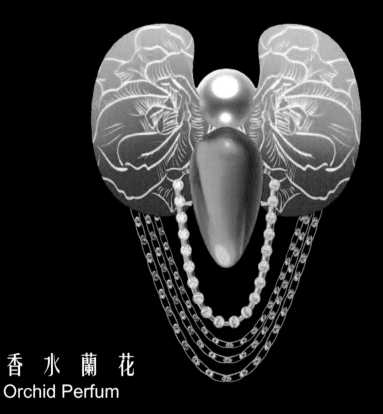

香 水 蘭 花
Orchid Perfum

白金，黃金，鑽石，紫玉髓，綠玉髓，鋁合金
Platinum, Gold, Diamond, Purple and green chalcedony, Aluminum

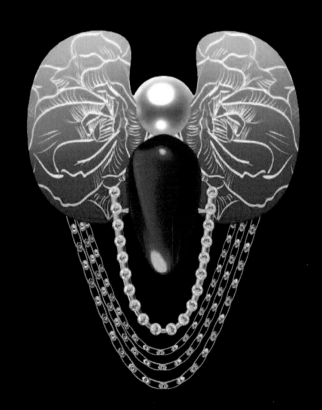

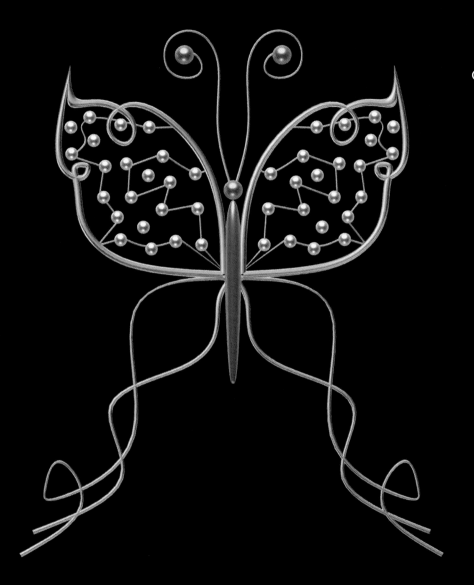

魔鬼蝴蝶
Shadowy Butterfly

彩色銀線，黑鋁合金
Colour silver wires, Black aluminum

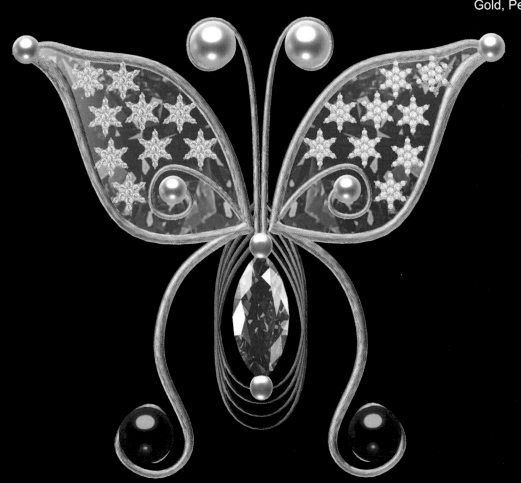

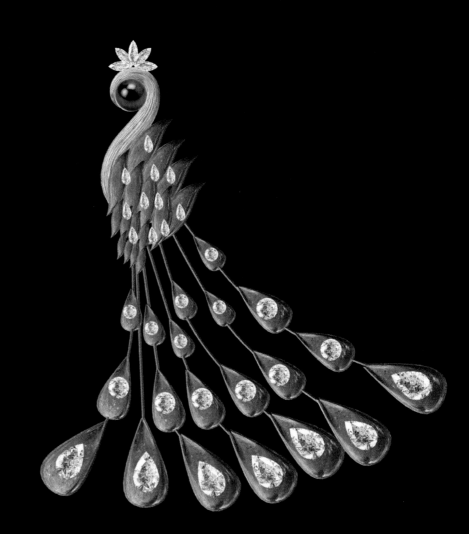

鳳 凰 儀
Phoenix

黃金，鑽石，黑珍珠，鋁合金
Gold, Diamond, Black pearl, Aluminum

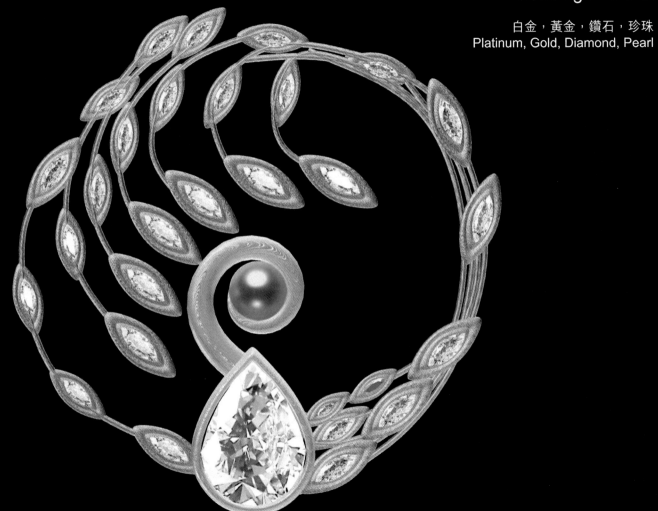

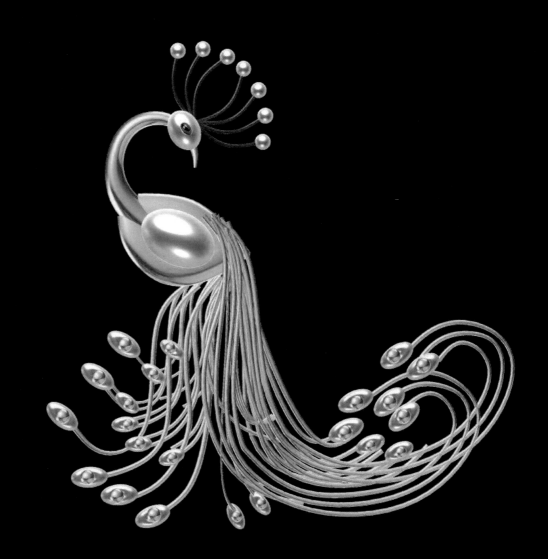

鳳 之 姿
Amazing Phoenix

白金，黃金，珍珠，銀線
Platinum, Gold, Pearl, Wires

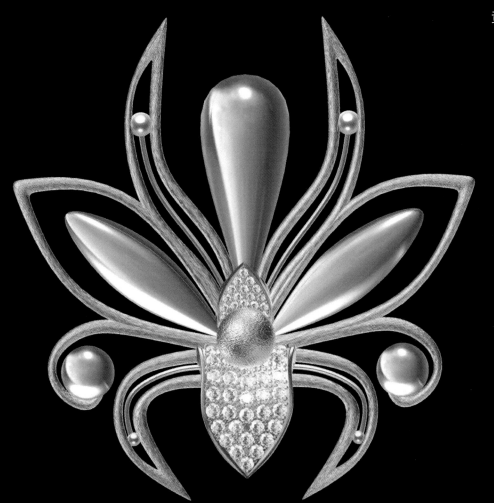

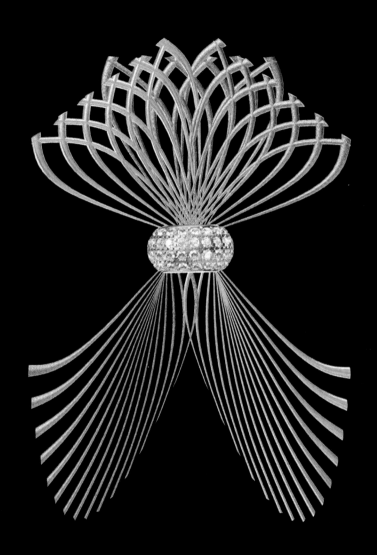

獻 花
Floral

白金，黃金，鑽石
Platinum, Gold, Diamond

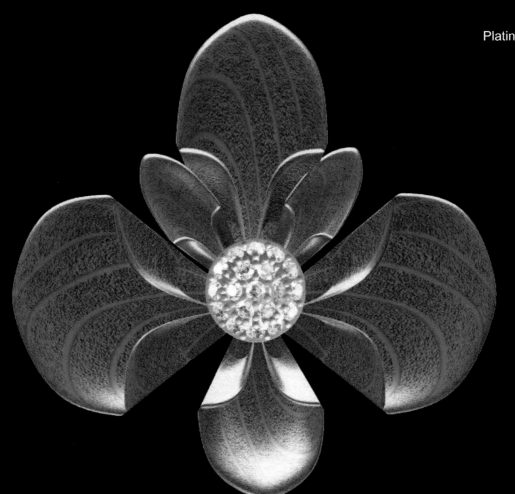

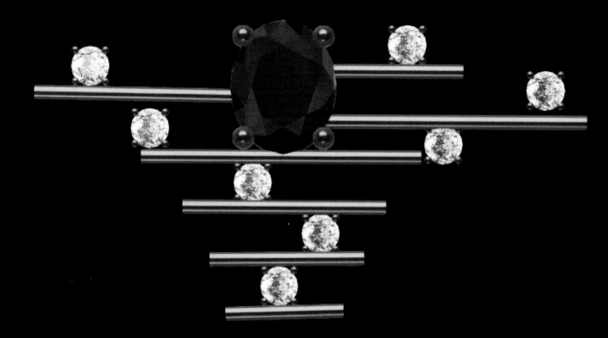

步 步 高 升
Promotion

玫瑰金，鑽石，紅寶石
Colour gold, Diamond, Ruby

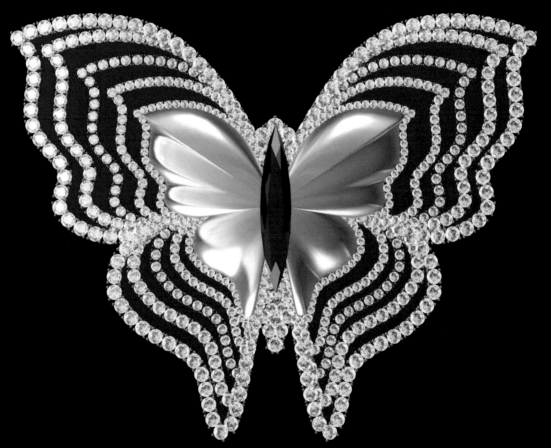

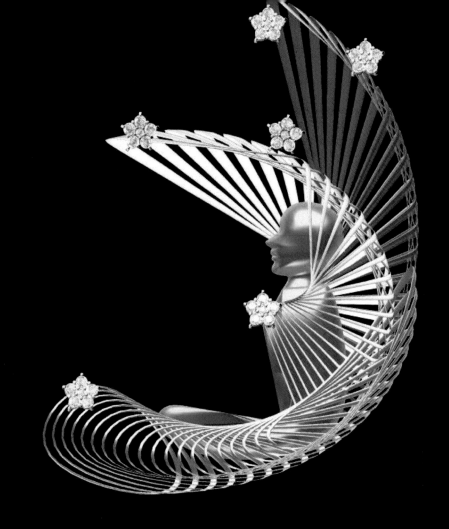

觀 星 者
Moon Traveller

白金，黃金，鑽石
Platinum, Gold, Diamond

呔夾

CLIP

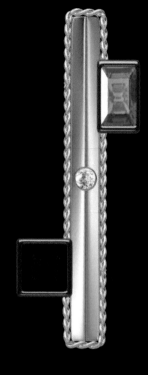

幾 何 圖 案
Geometric Patterns

白金，黃金，鑽石，紅寶石，藍寶石
Platinum, Gold, Diamond, Ruby, Sapphire

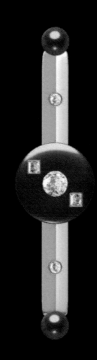

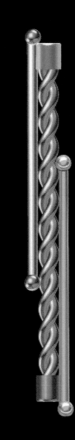

兩 線 的 匯 合
Twists

白金，黃金，珍珠
Platinum, Gold, Pearl

手鐲
CUFF

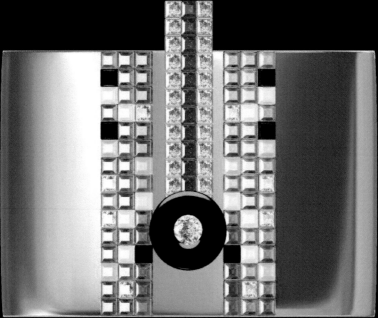

白金，黃金，鑽石，鋁合金
Platinum, Gold, Diamond, Aluminum

手鐲
Cuff　081

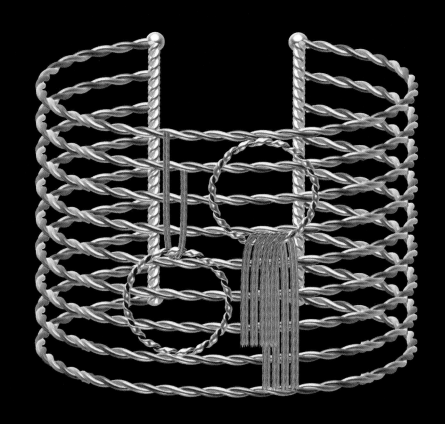

圈 中 圈
Throw-off Circle

白金，黃金，玫瑰金，珍珠
Platinum, Gold, Colour gold, Pearl

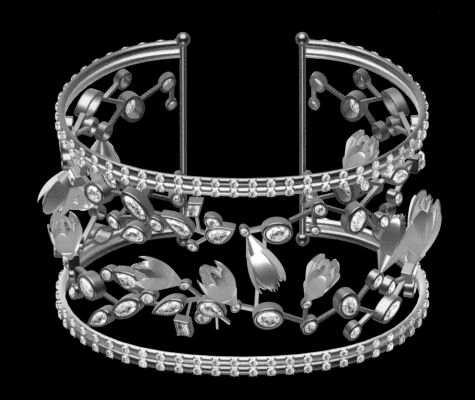

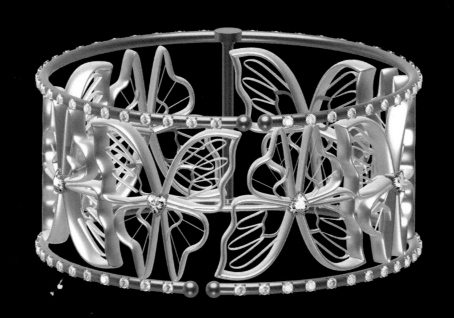

白 蝴 蝶 手 鐲
White Butterfly Cuff

白金，黃金，鑽石，珍珠
Platinum, Gold, Diamond, Pearl

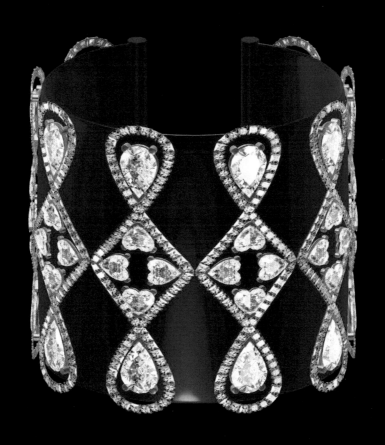

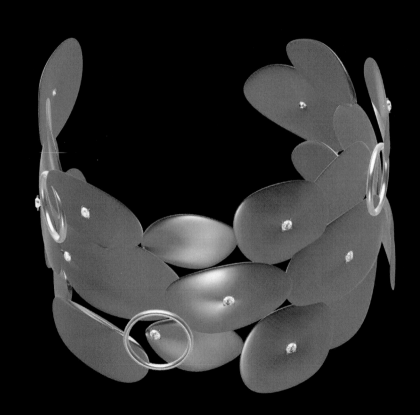

滴 水 成 金
Drops to Gold

白金，黃金，鑽石
Platinum, Gold, Diamond

耳環
EARRING

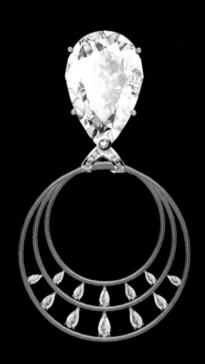
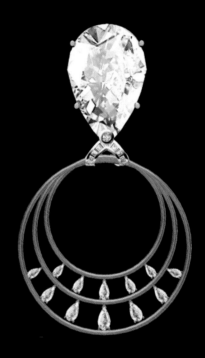

聚少成多
Accumulation

白金，玫瑰金，鑽石
Platinum, Colour gold, Diamond

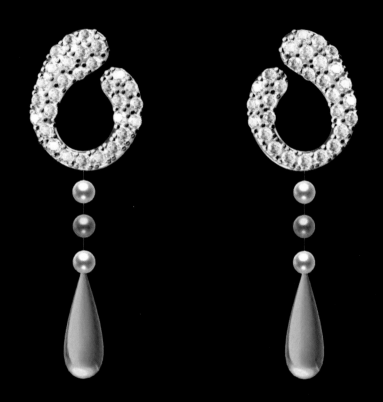

粉 紅 鑽 耳 環
Fancy Diamond Earring

白金，黃金，鑽石，粉紅鑽
Platinum, Gold, Diamond, Fancy diamond

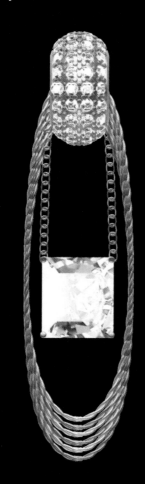
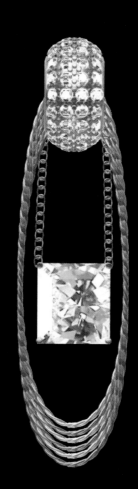

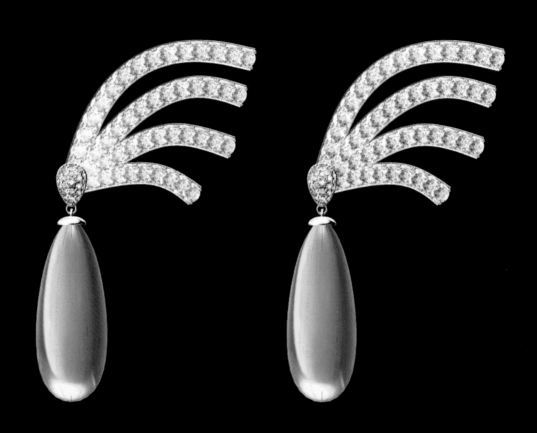

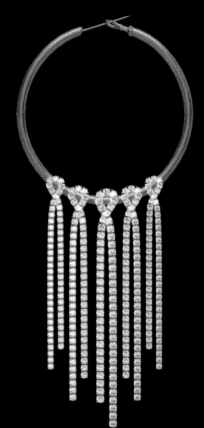

齊 齊 整 整
Good Order

白金，玫瑰金，鑽石
Platinum, Colour gold, Diamond

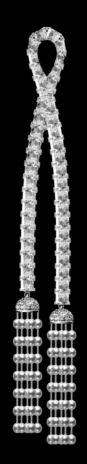
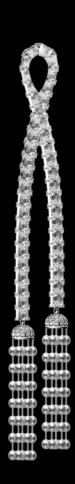

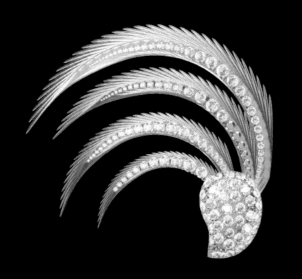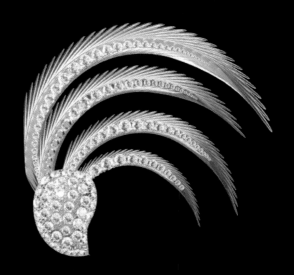

相 輝 映
Reflection

白金，黃金，鑽石
Platinum, Gold, Diamond

白金，黃金，玫瑰金，鑽石，黃白珍珠
Platinum, Gold, Colour Gold, Diamond,
Yellow and white pearl

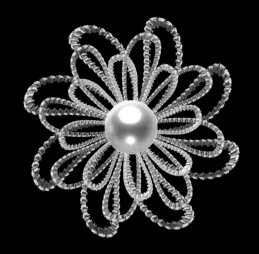
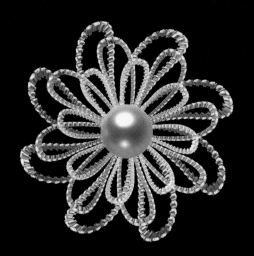

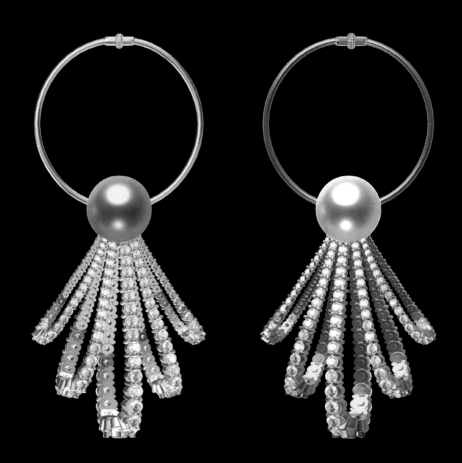

開 枝 散 葉
Flourishing

白金，黃金，鑽石，黃白珍珠
Platinum, Gold, Diamond,
Yellow and white pearl

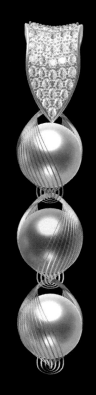
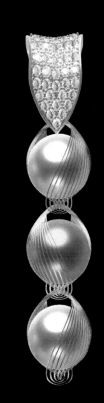

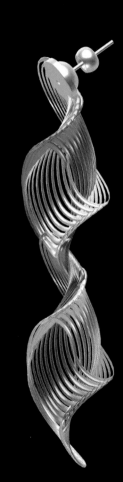
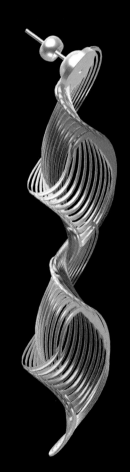

唇 齒 相 依
Happiness

白金，黃金，玫瑰金
Platinum, Gold, Colour gold

白金，黃珍珠，紅玉髓
Platinum, Yellow pearl,
Red chalcedony

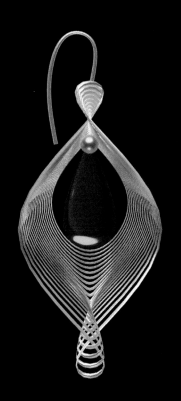
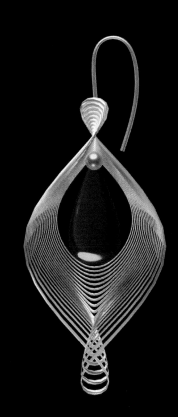

好 出 色
Twist to Colour

白金，黃金，鑽石，三色玉髓
Platinum, Gold, Diamond,
Colour chalcedony

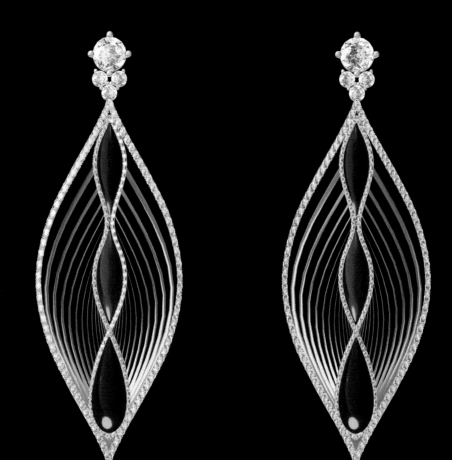

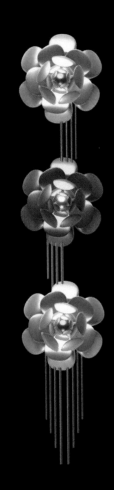

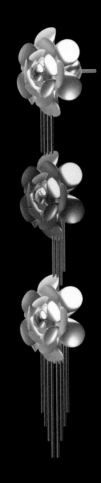

金 銀 花 卉
Golden Flowers

白金，黃金
Platinum, Gold

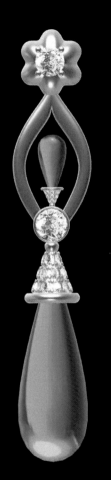
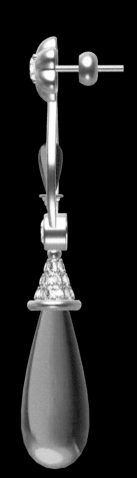

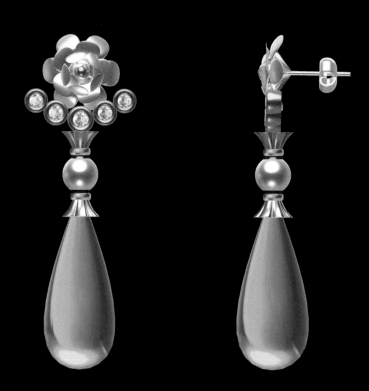

藍 仙 子
Blue Fairy

白金，玫瑰金，鑽石，珍珠，藍矽孔雀石
Platinum, Colour gold, Diamond, Pearl,
Blue chrysocolla

相 聚
Gathering

白金，黃金，黃白珍珠，藍玉髓，紫玉髓
Platinum, Gold, Yellow and white pearl,
Blue and purple chalcedony

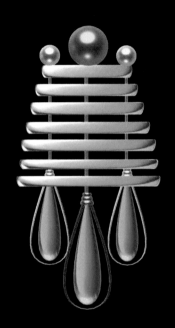
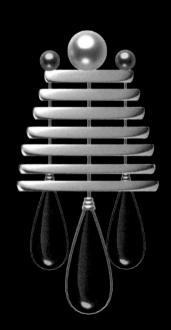

同 心 扣
Heart Chain

白金，黃金，水滴珠
Platinum, Gold, Gold drip

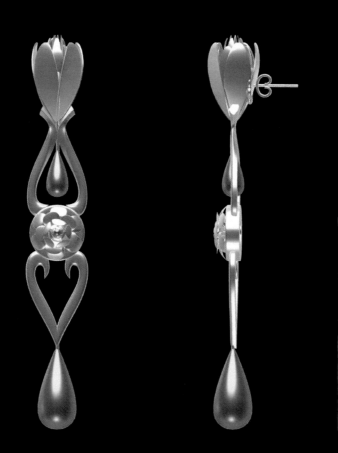

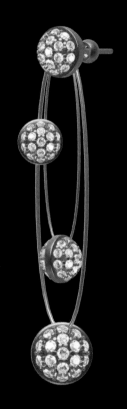
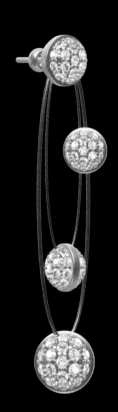

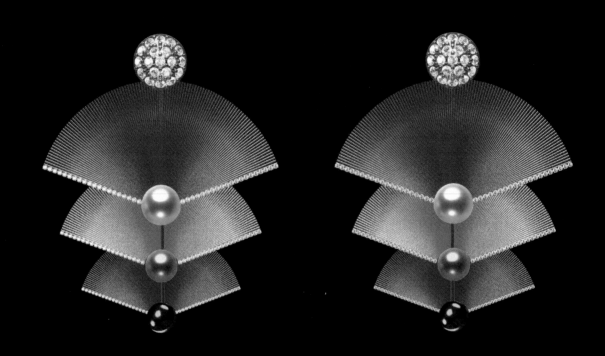

三　重　奏
Trio

白金，黃金，玫瑰金，鑽石，三色珍珠
Platinum, Gold, Colour gold, Diamond,
Colour pearl

108

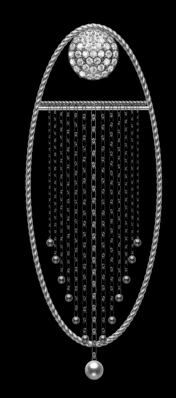
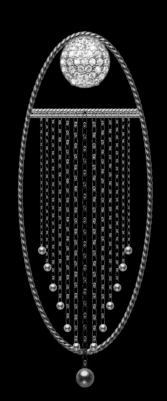

耀 舞 揚 威
Big Show

白金，玫瑰金，鑽石和彩色銀線
Platinum, Colour gold, Diamond,
Colour wires

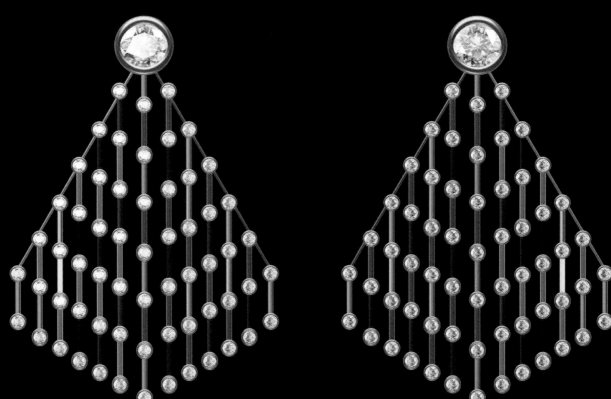

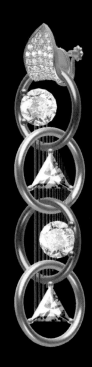
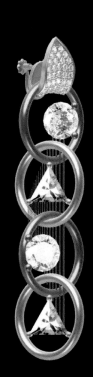

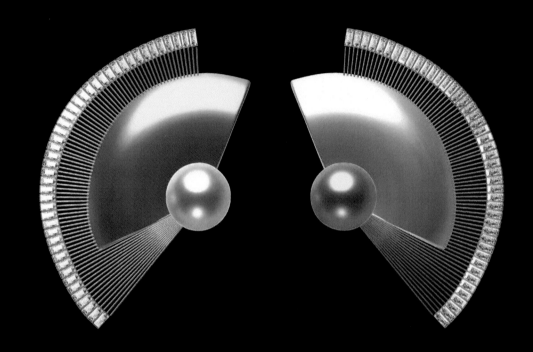

陰 陽 扇
Match Fan

白金，黃金，鑽石，黃白珍珠
Platinum, Gold, Diamond,
Yellow and white pearl

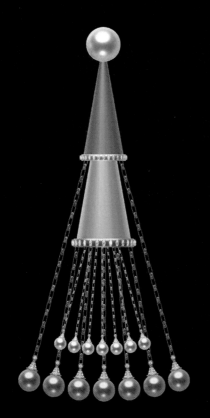
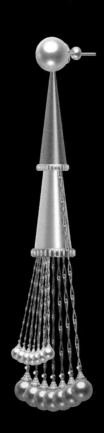

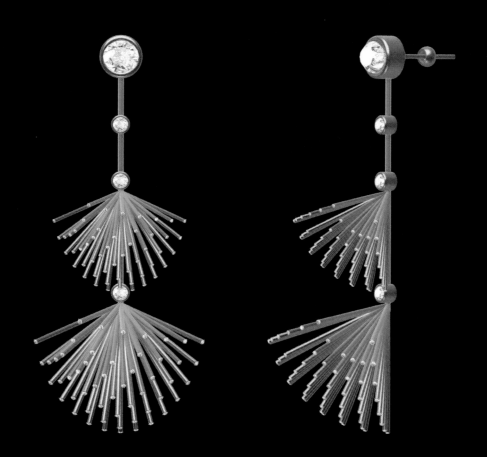

光 彩
Sparkle

白金，黃金，鑽石
Platinum, Gold, Diamond

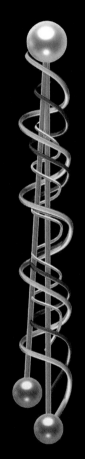
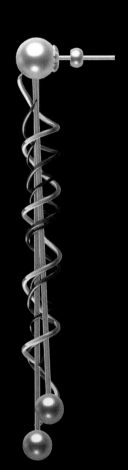

白金，彩色銀線，黃白珍珠
Platinum, Colour wires,
Yellow and white pearl

心 花 怒 放
Elated

白金，黃金，玫瑰金，鑽石
Platinum, Gold, Colour gold, Diamond

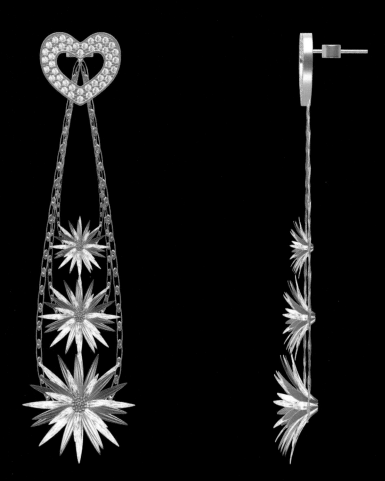

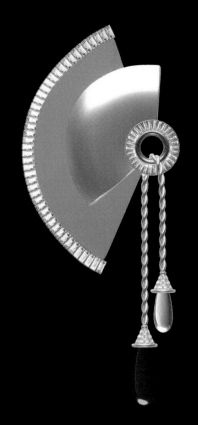
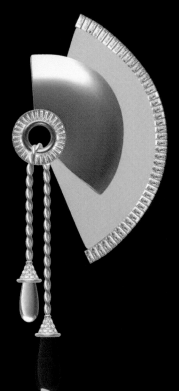

爭 艷
Competition

白金，黃金，玫瑰金，鑽石，紅白玉髓
Platinum, Gold, Colour gold, Diamond,
White and red chalcedony

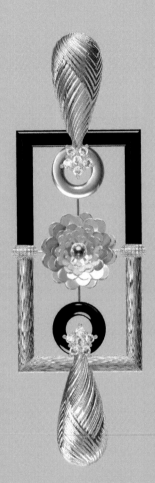

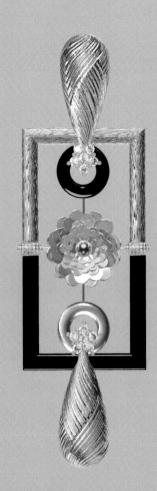

花 開 四 季
Season Flowers

白金，黃金，鑽石，安力士
Platinum, Gold, Diamond, Onyx

白金，黃金，鑽石，黑珍珠
Platinum, Gold, Diamond, Black pearl

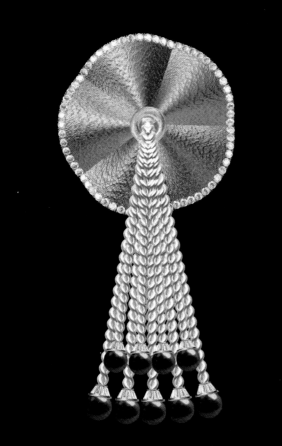

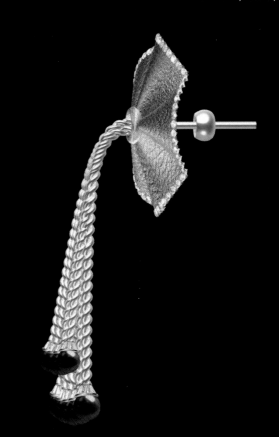

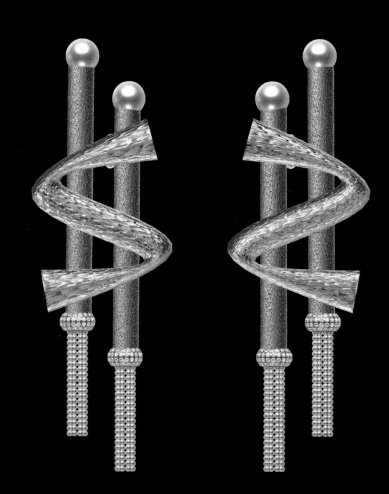

譜 出 樂 曲
Melody

白金，黃金，珍珠，鑽石
Platinum, Gold, Pearl, Diamond

白金，黃金，玫瑰金，安力士
Platinum, Gold, Colour gold, Onyx

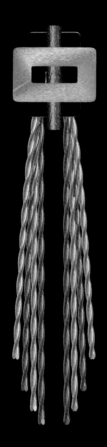

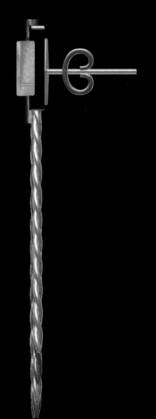

頸 鏈

NECKLACE

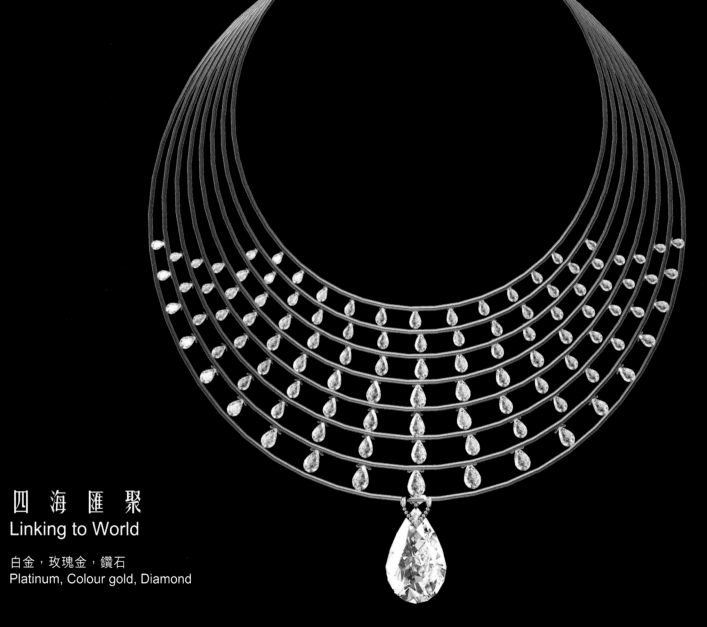

四 海 匯 聚
Linking to World

白金，玫瑰金，鑽石
Platinum, Colour gold, Diamond

藍玉髓頸圈
Blue Chrysocolla Collar

白金，黃金，珍珠，鑽石，藍矽孔雀石
Platinum, Gold, Pearl, Diamond,
Blue chrysocolla

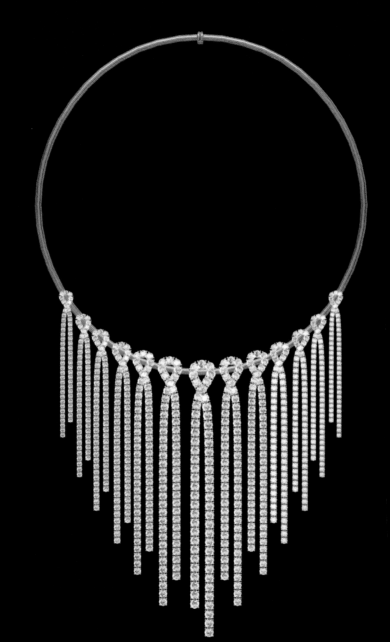

願 望 成 真
Wish Comes True

白金，玫瑰金，鑽石
Platinum, Colour gold, Diamond

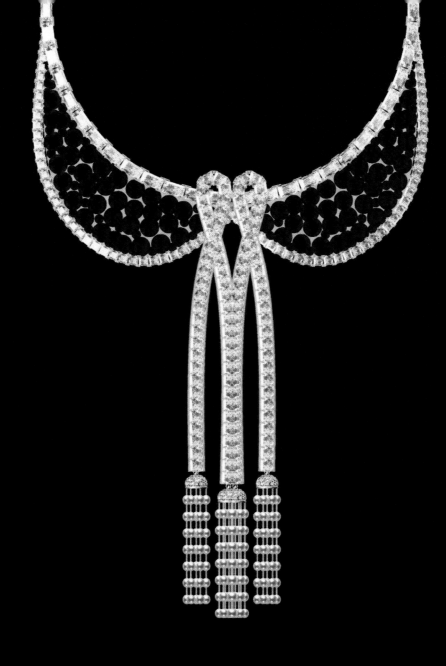

領 先 同 群
Number One

白金，鑽石，珍珠，紅寶石
Platinum, Diamond, Pearl, Ruby

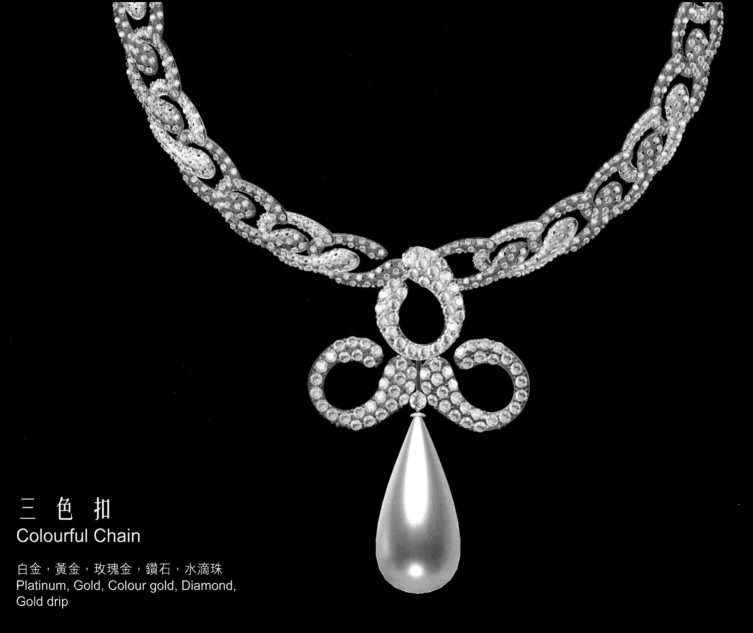

三　色　扣
Colourful Chain

白金，黃金，玫瑰金，鑽石，水滴珠
Platinum, Gold, Colour gold, Diamond,
Gold drip

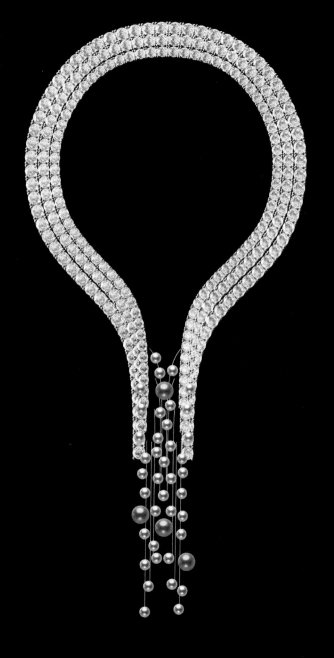

順 利 圓 滿
Successful

白金，鑽石，黃白珍珠
Platinum, Diamond,
Yellow and white pearl

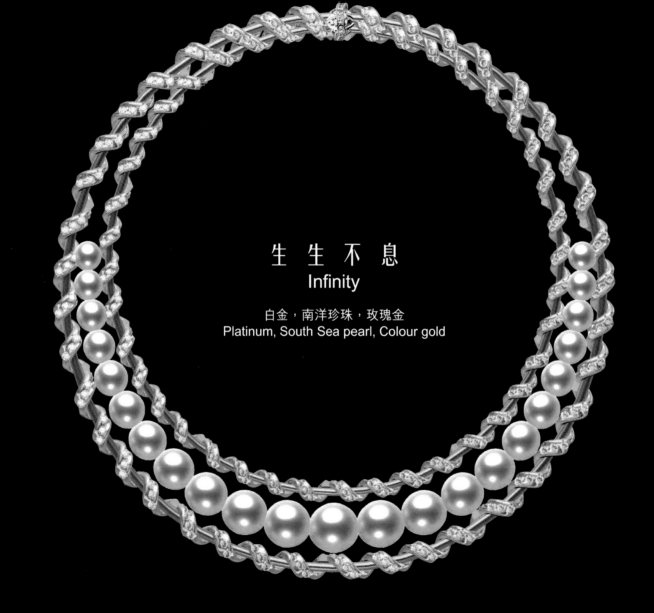

生 生 不 息
Infinity

白金，南洋珍珠，玫瑰金
Platinum, South Sea pearl, Colour gold

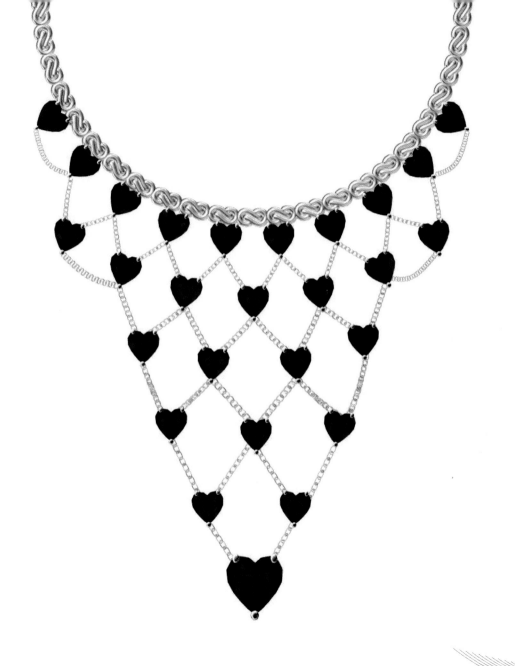

愛 心
Kindness

白金，紅寶石
Platinum, Ruby

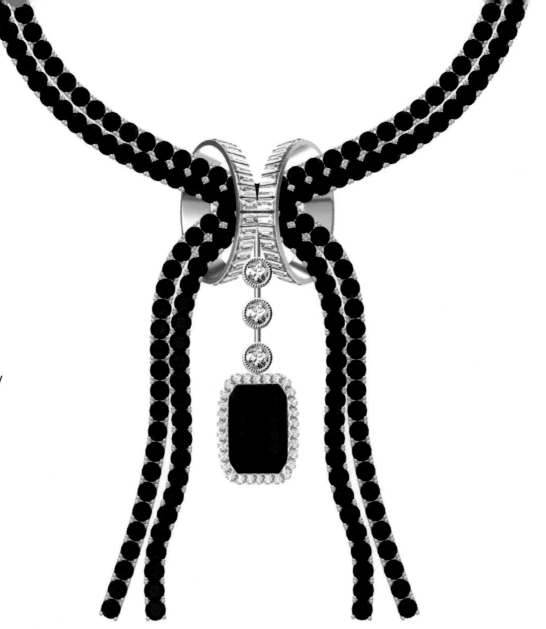

川 流 不 息
Endless

白金，鑽石，紅寶石
Platinum, Diamond, Ruby

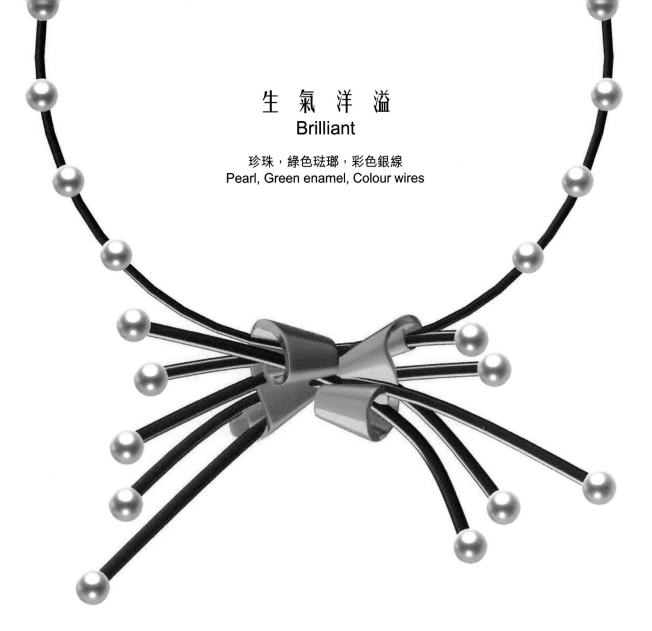

生 氣 洋 溢
Brilliant

珍珠，綠色琺瑯，彩色銀線
Pearl, Green enamel, Colour wires

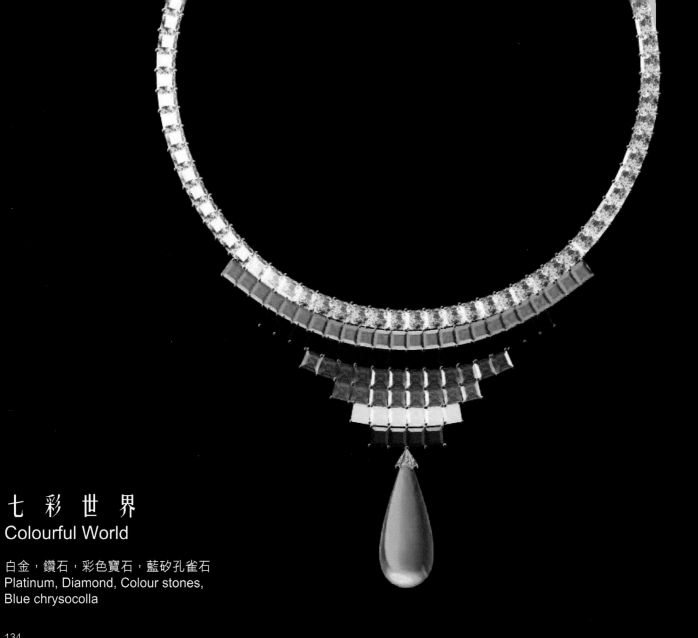

七 彩 世 界
Colourful World

白金，鑽石，彩色寶石，藍矽孔雀石
Platinum, Diamond, Colour stones,
Blue chrysocolla

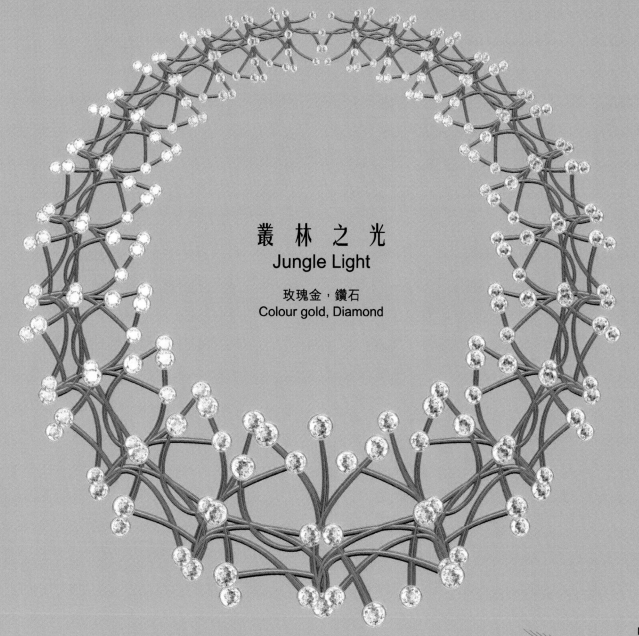

叢 林 之 光
Jungle Light

玫瑰金，鑽石
Colour gold, Diamond

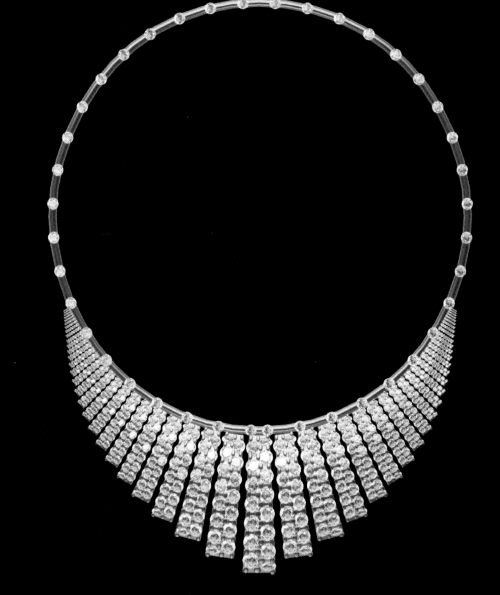

百 川 匯 聚
Collection

玫瑰金，鑽石
Colour gold, Diamond

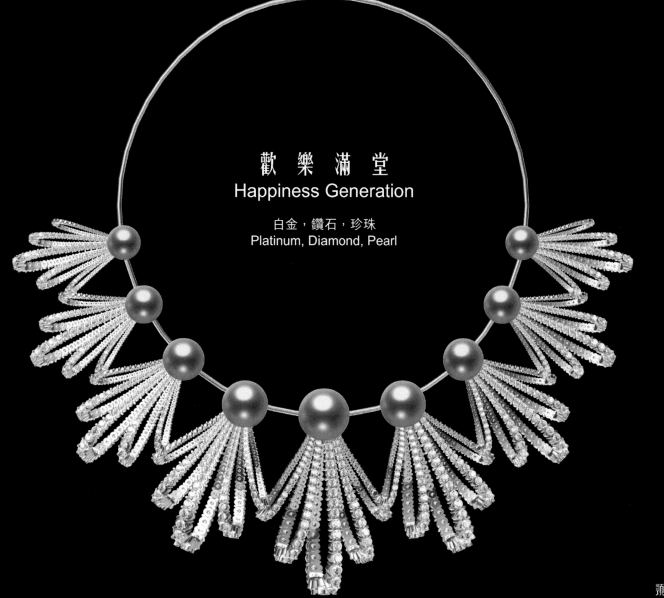

歡 樂 滿 堂
Happiness Generation

白金，鑽石，珍珠
Platinum, Diamond, Pearl

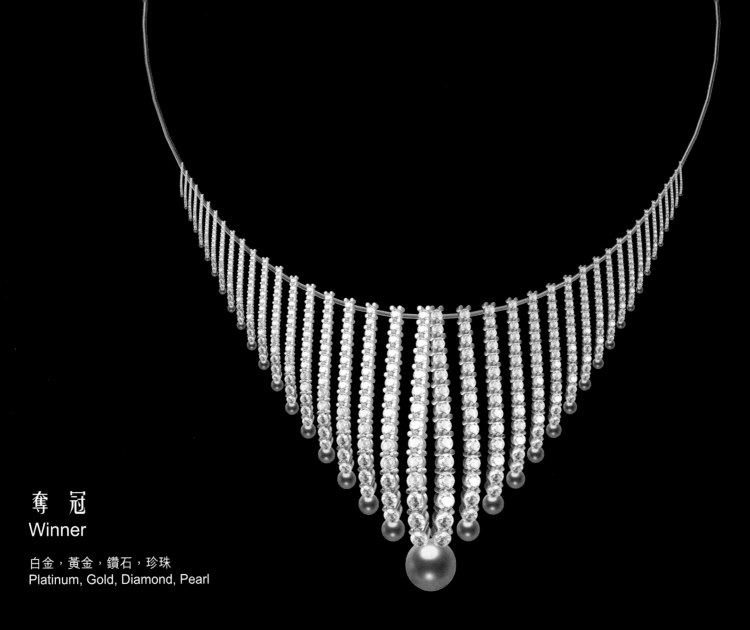

奪 冠
Winner

白金，黃金，鑽石，珍珠
Platinum, Gold, Diamond, Pearl

水 之 源
Water of Life

白金，玫瑰金，鑽石
Platinum, Colour gold, Diamond

萬 子 千 孫
Fruitfulness

白金，鑽石，珍珠，藍寶石
Platinum, Diamond, Pearl, Sapphire

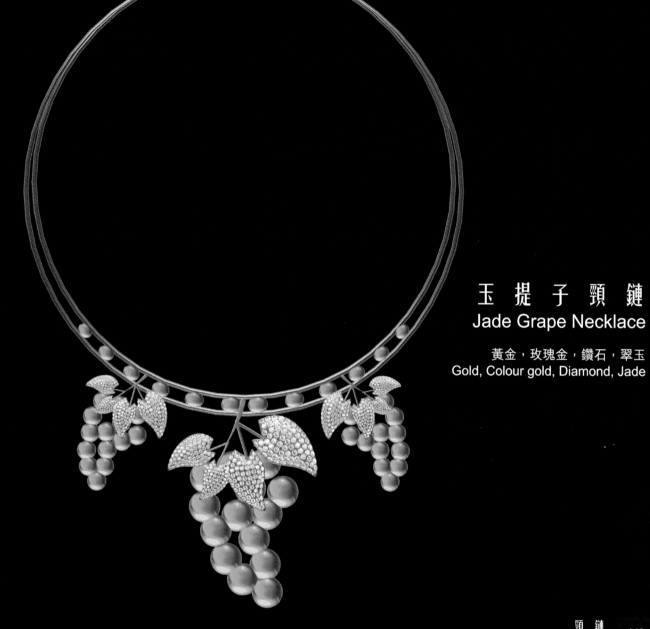

玉 提 子 頸 鏈
Jade Grape Necklace

黃金，玫瑰金，鑽石，翠玉
Gold, Colour gold, Diamond, Jade

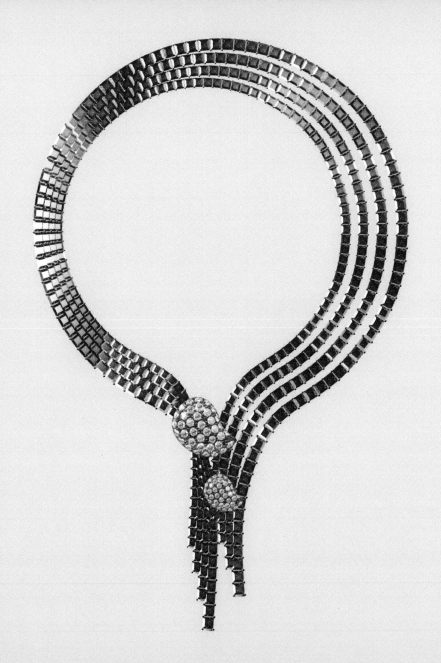

聯 盟
Alliance

黃金，鑽石，藍寶石
Gold, Diamond, Sapphire

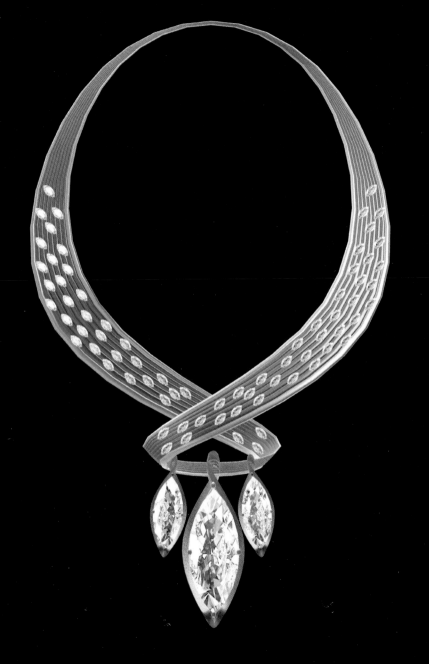

美 鑽 匯 聚
Art of Diamond

白金，玫瑰金，鑽石
Platinum, Colour gold, Diamond

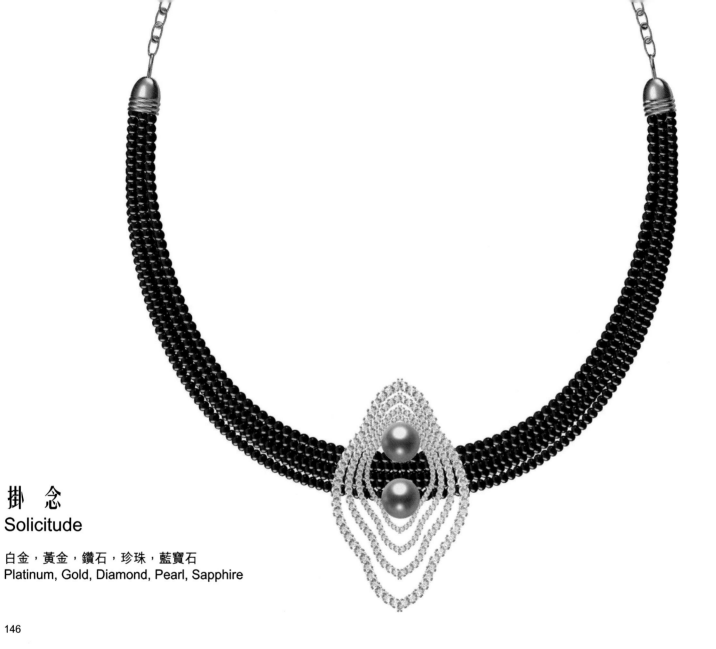

掛　念
Solicitude

白金，黃金，鑽石，珍珠，藍寶石
Platinum, Gold, Diamond, Pearl, Sapphire

白金，黃金，鑽石
Platinum, Gold, Diamond

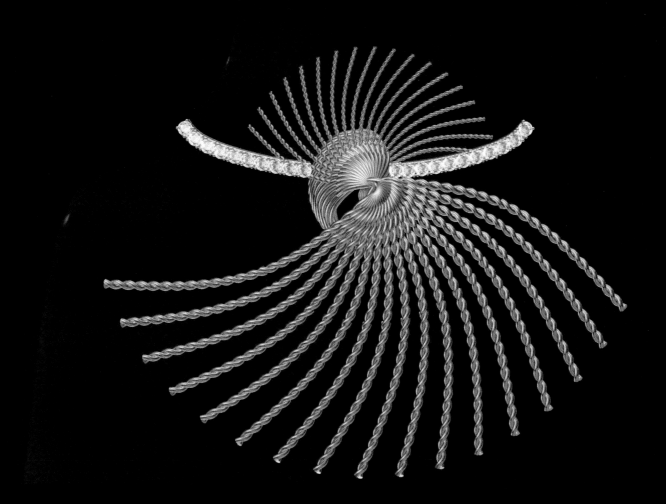

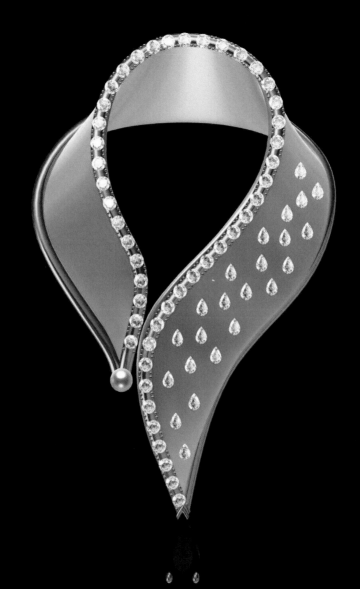

領 先 者
Go Ahead

白金，黃金，鑽石，紅寶石，珍珠
Platinum, Gold, Diamond, Ruby, Pearl

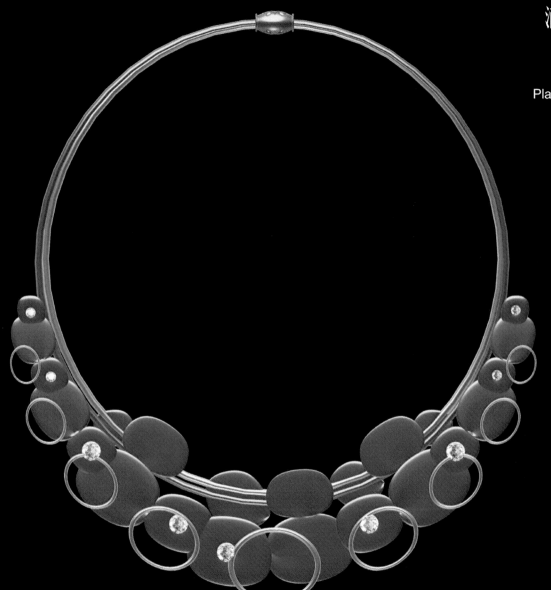

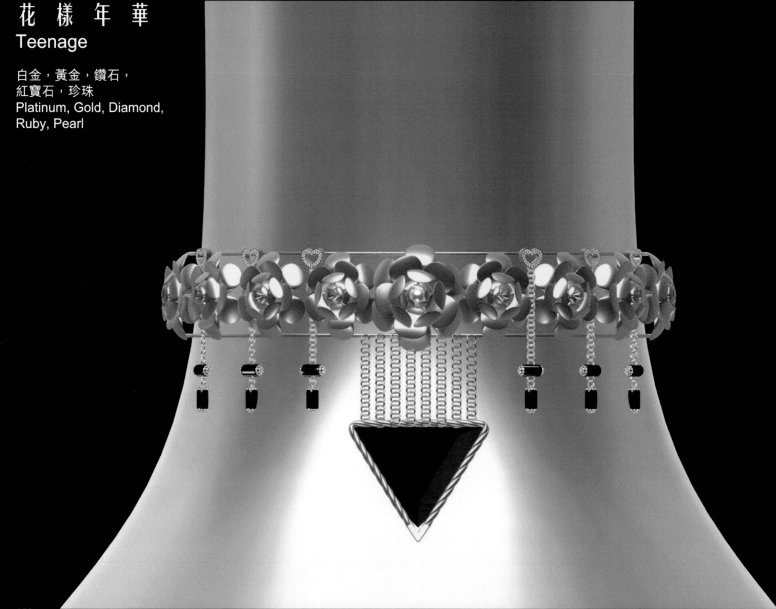

花 樣 年 華
Teenage

白金，黃金，鑽石，
紅寶石，珍珠
Platinum, Gold, Diamond,
Ruby, Pearl

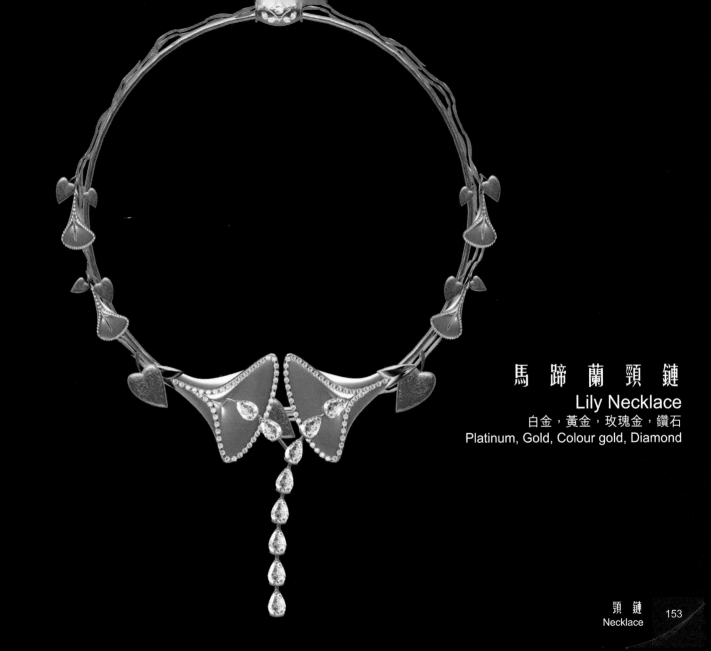

馬 蹄 蘭 頸 鏈
Lily Necklace
白金，黃金，玫瑰金，鑽石
Platinum, Gold, Colour gold, Diamond

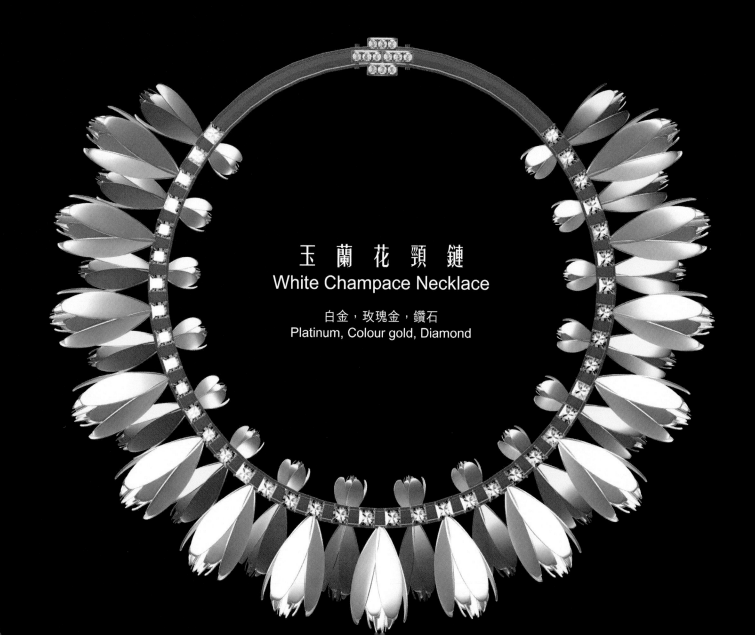

玉 蘭 花 頸 鏈
White Champace Necklace

白金，玫瑰金，鑽石
Platinum, Colour gold, Diamond

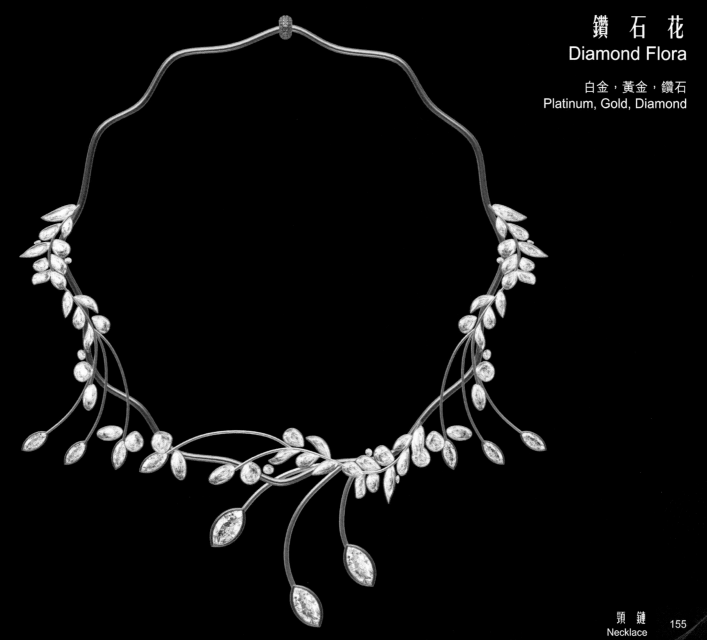

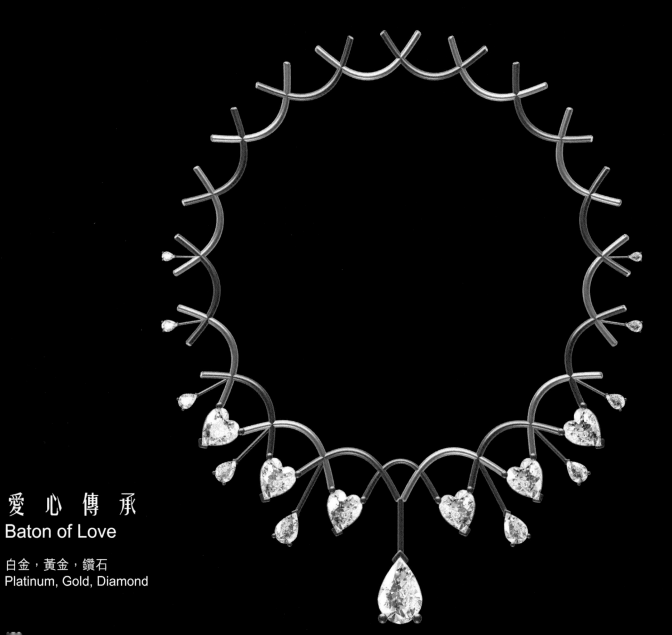

愛 心 傳 承
Baton of Love

白金，黃金，鑽石
Platinum, Gold, Diamond

白金，黃金，玫瑰金，藍矽孔雀石
Platinum, Gold, Colour gold,
Blue chrysocolla

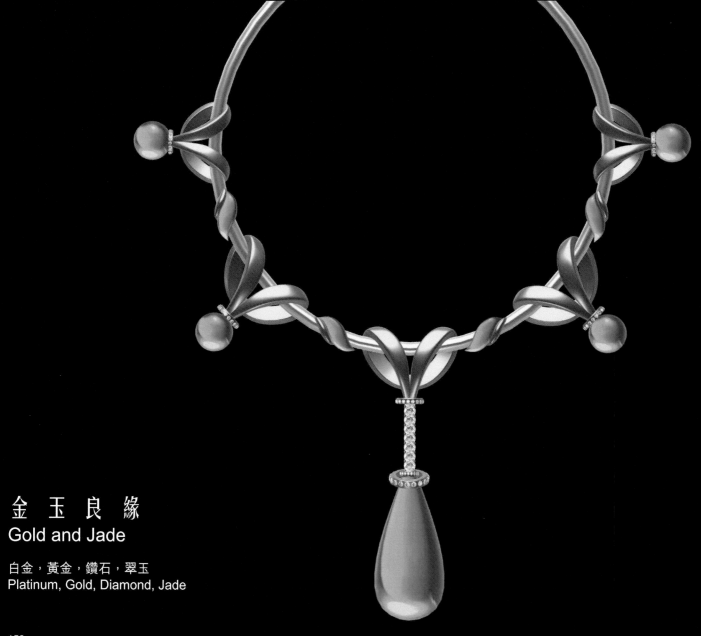

金 玉 良 緣
Gold and Jade

白金，黃金，鑽石，翠玉
Platinum, Gold, Diamond, Jade

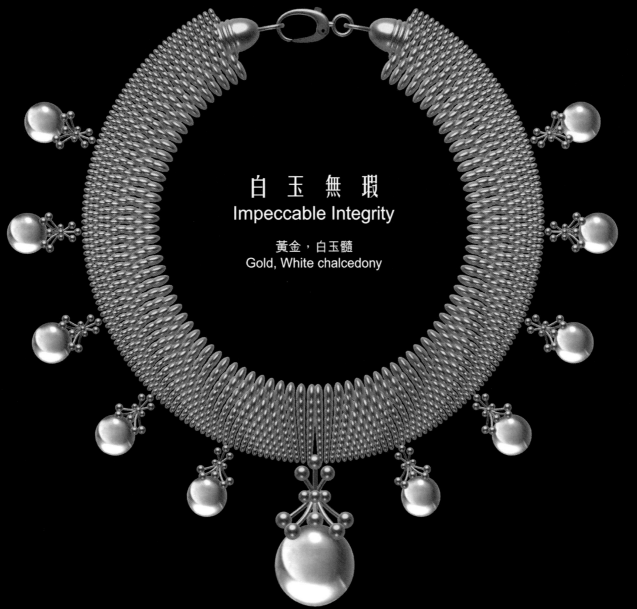

白 玉 無 瑕
Impeccable Integrity

黃金，白玉髓
Gold, White chalcedony

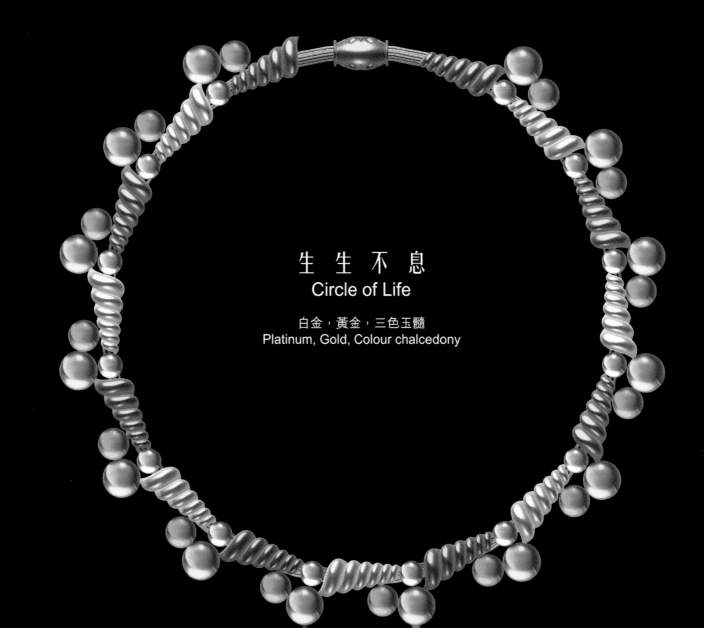

生 生 不 息
Circle of Life

白金，黃金，三色玉髓
Platinum, Gold, Colour chalcedony

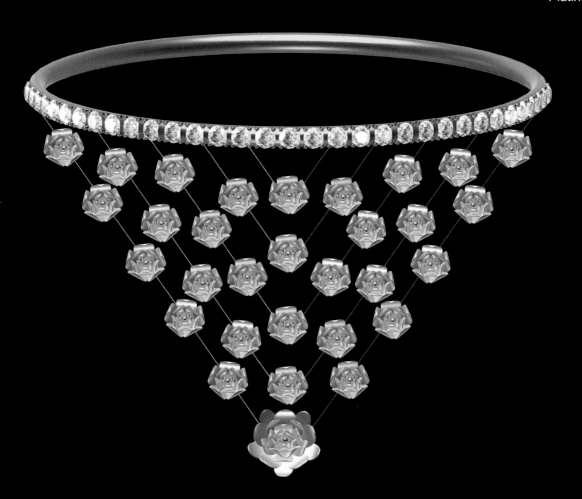

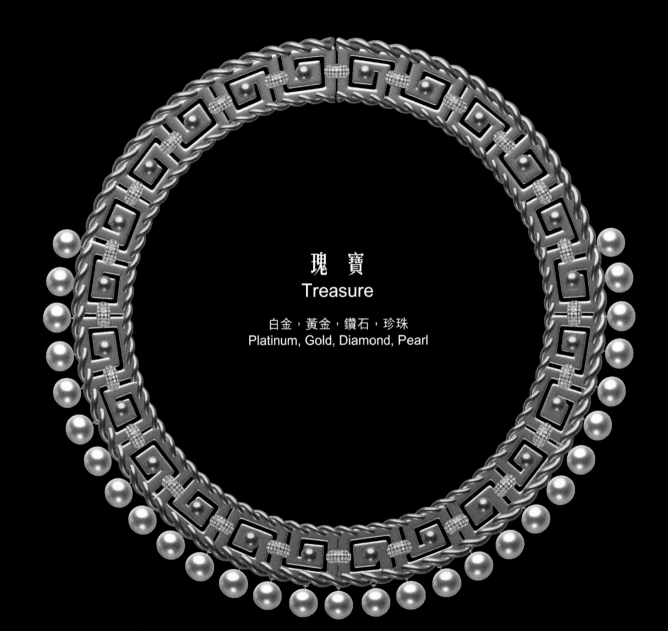

瑰　寶
Treasure

白金，黃金，鑽石，珍珠
Platinum, Gold, Diamond, Pearl

脫 俗 頸 鏈
Ethereal Necklace

白金，黃金，玫瑰金，鑽石，
黃白玉髓，黑銀線
Platinum, Gold, Colour gold, Diamond,
Yellow and white chalcedony,
Black silver wires

幾 何 圖 形
Geometric Patterns

白金，黃金，鑽石，紅寶石，
藍寶石，安力士
Platinum, Gold, Diamond, Ruby,
Sapphire, Onyx

點綴其中
Art of Decoration

白金，黃金，鑽石，
珍珠，藍寶石
Platinum, Gold, Diamond,
Pearl, Sapphire

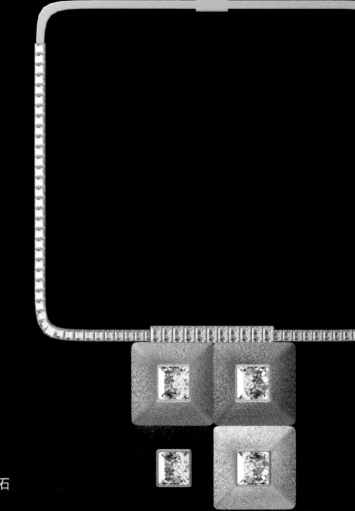

四　季
Four Seasons

白金，黃金，玫瑰金，黑金，鑽石
Platinum, Gold, Colour gold,

層 次 分 明
Layers

白金，黃金，黑金，鑽石
Platinum, Gold, Black gold, Diamond

百 寶 袋
Treasure Bag

白金，黃金，珍珠，紅寶石，翠玉
Platinum, Gold, Pearl, Ruby, Jade

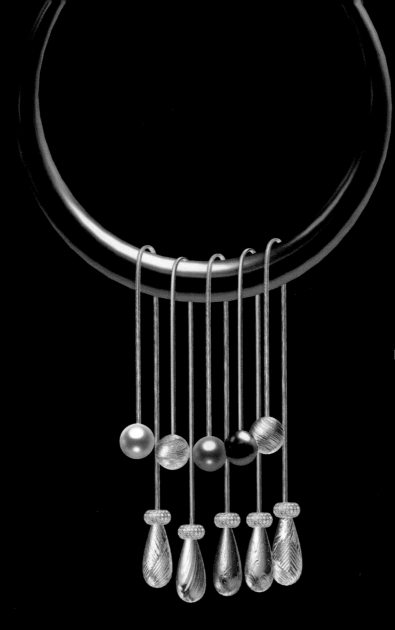

點 綴 平 衡
Art of Balance

白金，黃金，黑金，鑽石，三色珍珠
Platinum, Gold, Black gold, Diamond,
Colour pearl

頸 鏈　169
Necklace

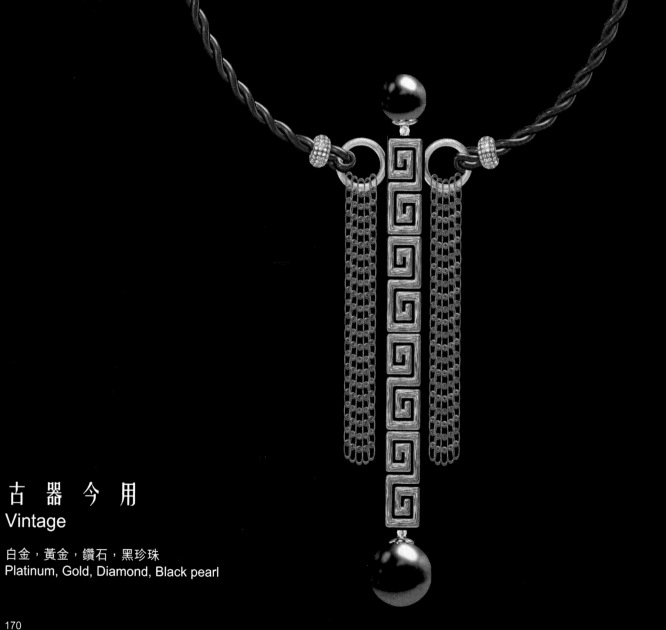

古 器 今 用
Vintage

白金，黃金，鑽石，黑珍珠
Platinum, Gold, Diamond, Black pearl

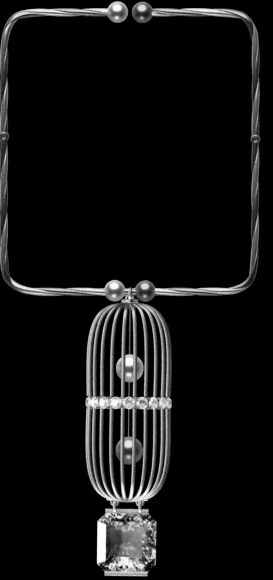

紅 碧 璽 四 方
Tourmaline Square

白金，黃金，珍珠，
Platinum, Gold, Pearl, Diamond

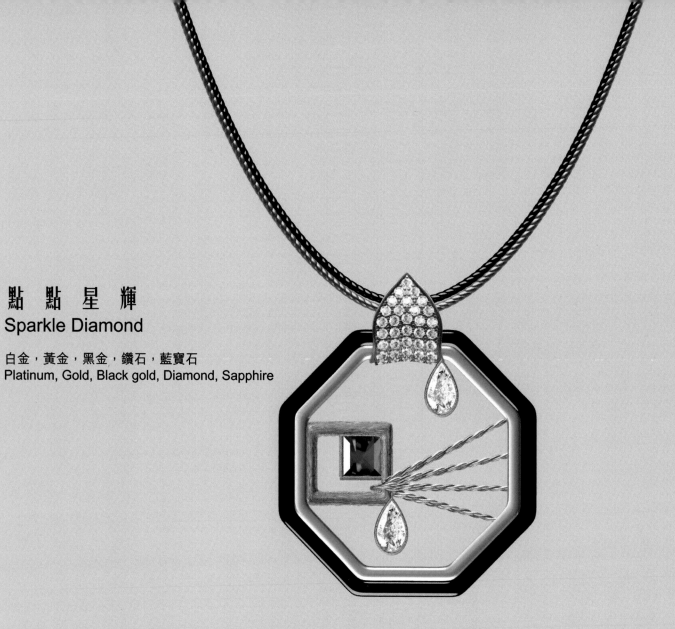

點 點 星 輝
Sparkle Diamond

白金，黃金，黑金，鑽石，藍寶石
Platinum, Gold, Black gold, Diamond, Sapphire

白金，黃金
Platinum, Gold

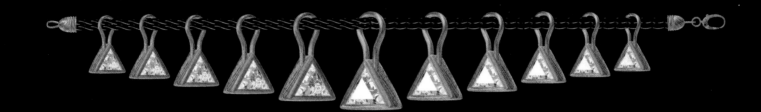

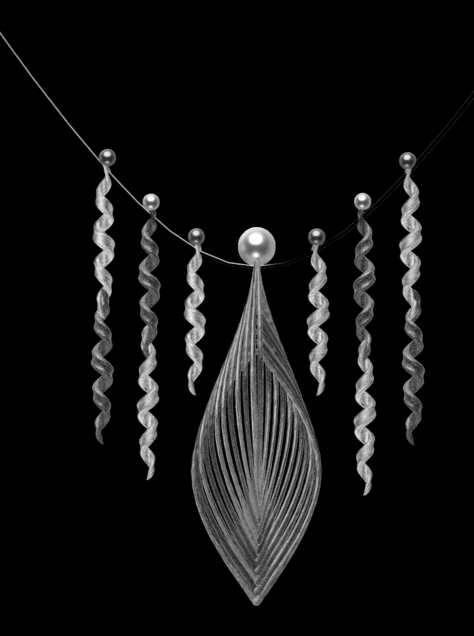

金 葉
Gold Leaf

白金，黃金，珍珠
Platinum, Gold, Pearl

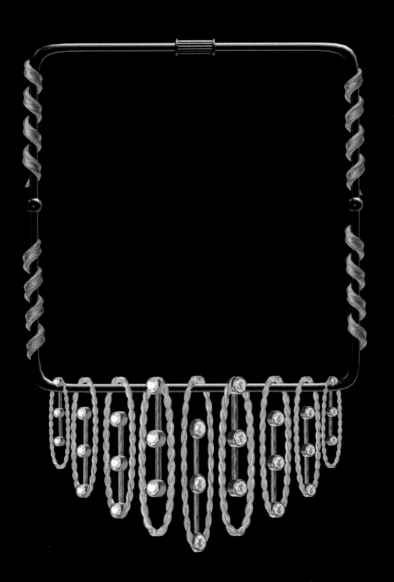

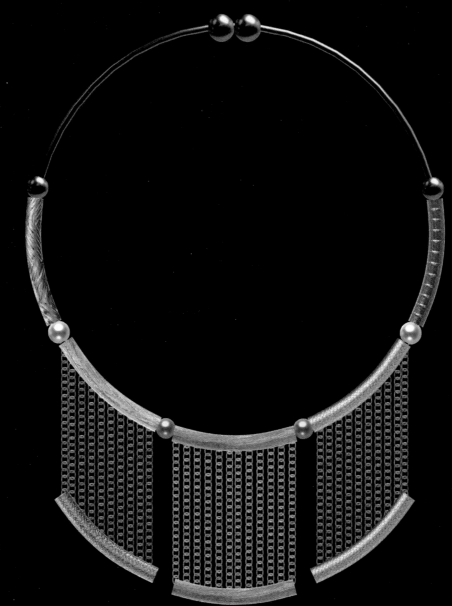

古 式 古 香
Vintage Style

白金，黃金，黑金，三色珍珠
Platinum, Gold, Black gold,
Colour pearl

吊墜和襟針兩用

PENDANT & BROOCH (USE IN BOTH)

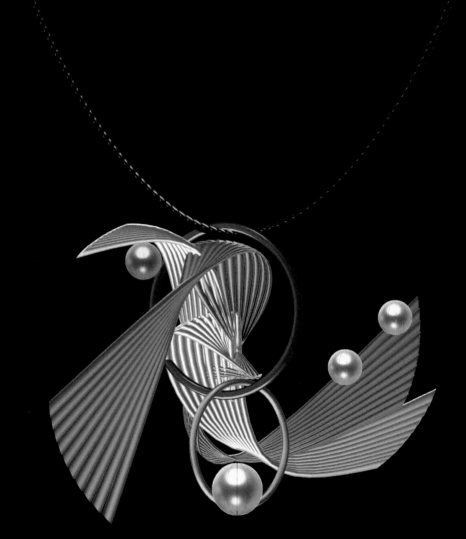

魚 躍 龍 門
Dive Forward

白金，黃金，珍珠，銀線圈
Platinum, Gold, Pearl, Colour silver chain

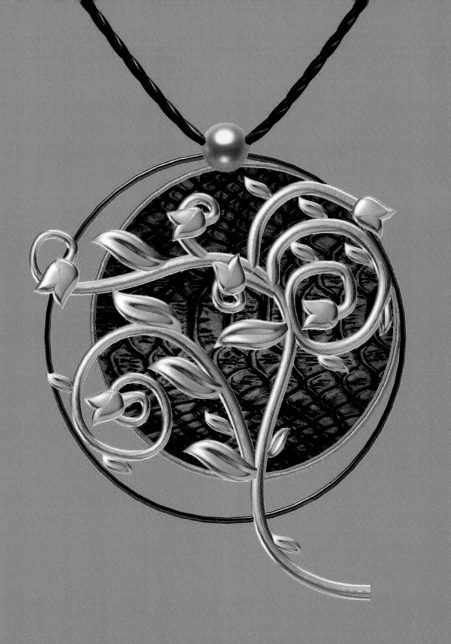

皮 影 花
Shadow Flower

白金，黃金，珍珠，皮革
Platinum, Gold, Pearl, Leather

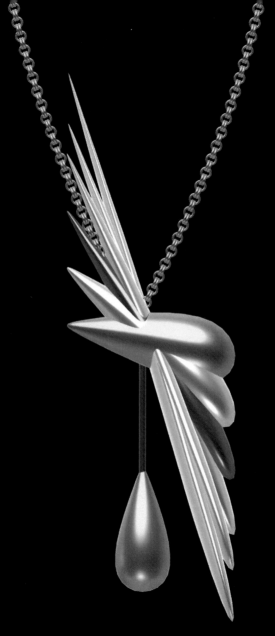

展 翅
Fly Up

白金，黃金，玫瑰金
Platinum, Gold, Colour gold

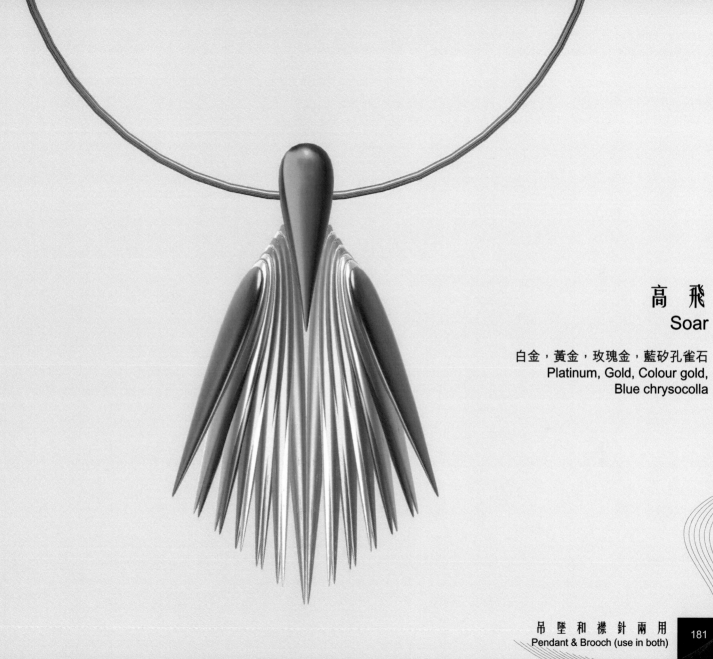

高 飛
Soar

白金，黃金，玫瑰金，藍矽孔雀石
Platinum, Gold, Colour gold,
Blue chrysocolla

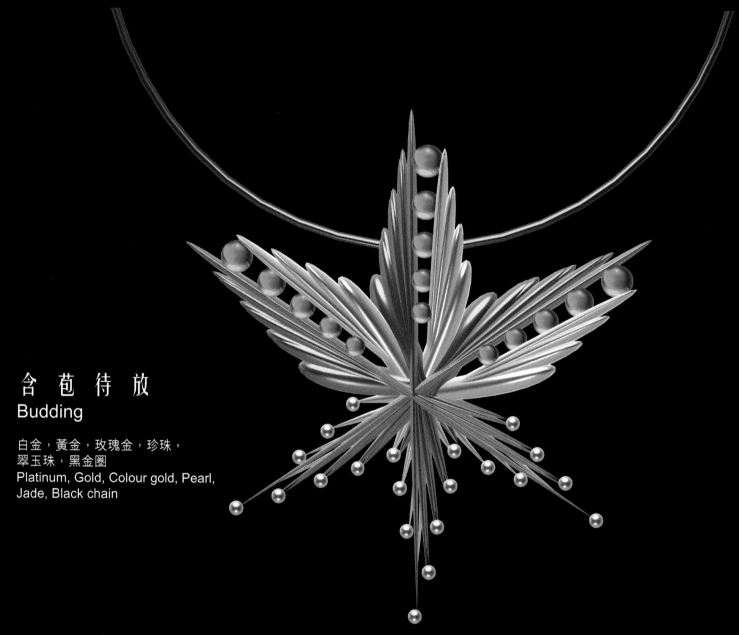

含 苞 待 放
Budding

白金，黃金，玫瑰金，珍珠，
翠玉珠，黑金圈
Platinum, Gold, Colour gold, Pearl,
Jade, Black chain

182

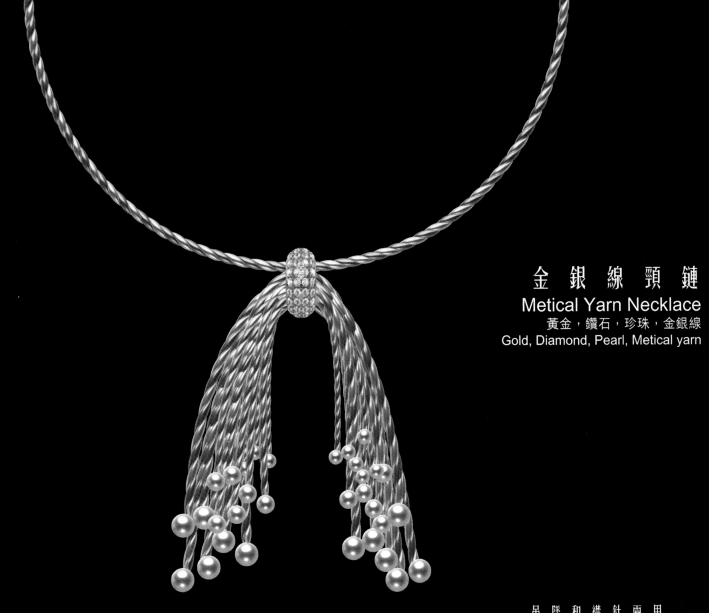

金銀線頸鏈
Metical Yarn Necklace
黃金，鑽石，珍珠，金銀線
Gold, Diamond, Pearl, Metical yarn

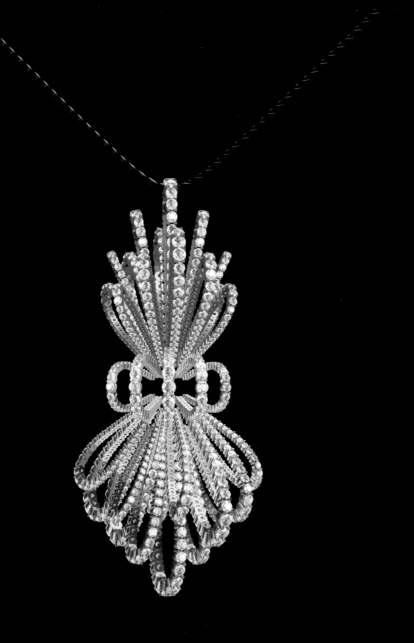

倒 影
Art of Reflection

白金，黃金，玫瑰金，鑽石
Platinum, Gold, Colour gold, Diamond

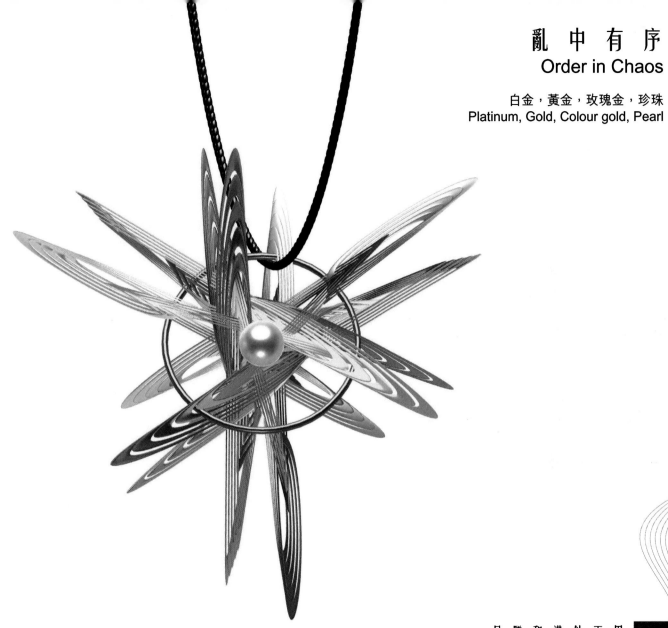

亂 中 有 序
Order in Chaos

白金，黃金，玫瑰金，珍珠
Platinum, Gold, Colour gold, Pearl

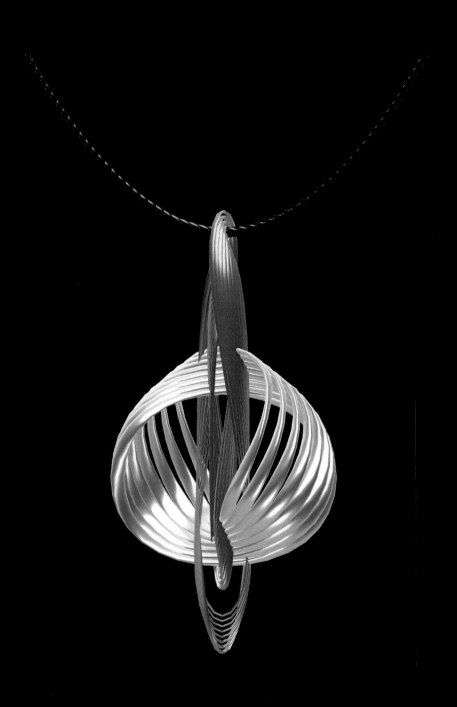

穿 越 時 空
Voyage

白金，黃金，玫瑰金
Platinum, Gold, Colour gold

186

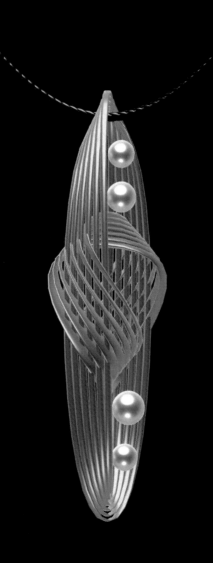

豆 之 美
Art of Bean

黃金，玫瑰金，珍珠
Gold, Colour gold, Pearl

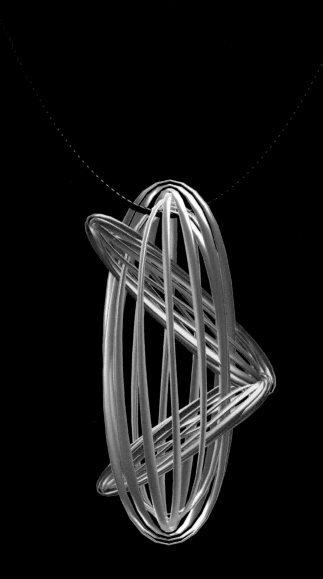

金 錢 以 外
In and Out

白金，黃金，玫瑰金
Platinum, Gold, Colour gold

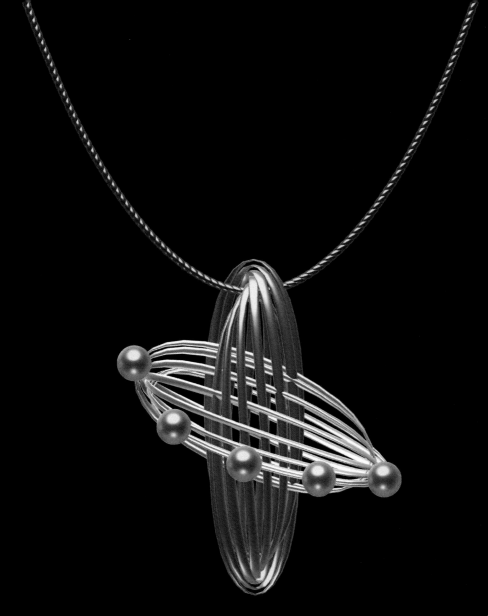

三 維 空 間
3D Oval

白金，玫瑰金，珍珠
Platinum, Colour gold, Pearl

翩　舞
3D Waltzing

白金，黃金，玫瑰金，鑽石
Platinum, Gold, Colour gold,
Diamond

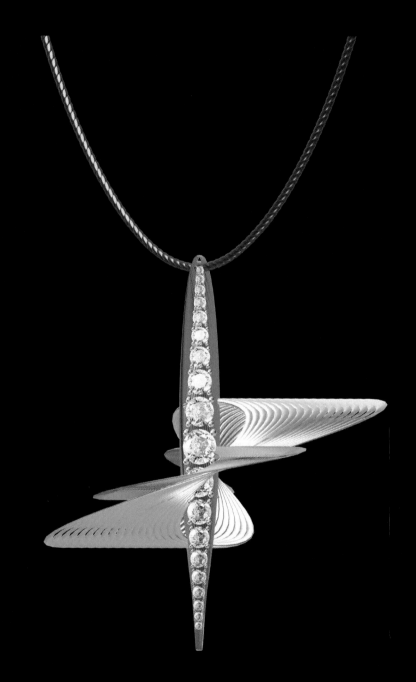

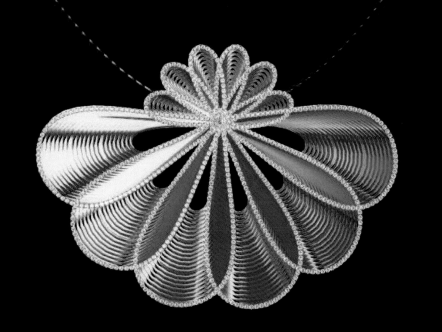

花 朵 綻 放
Blossoming

玫瑰金，鑽石
Colour gold, Diamond

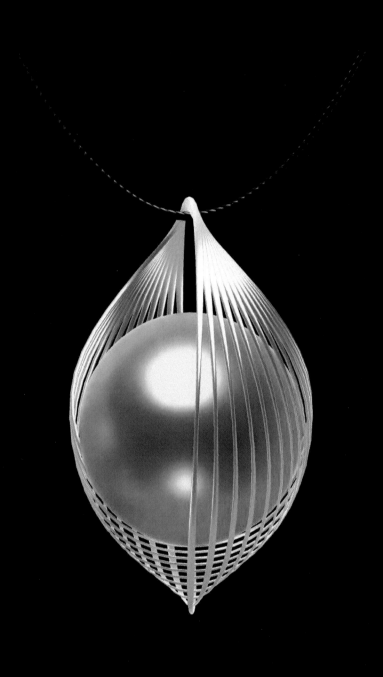

金 珠 點 綴
Decoration of Pearl

白金，珍珠
Platinum, Pearl

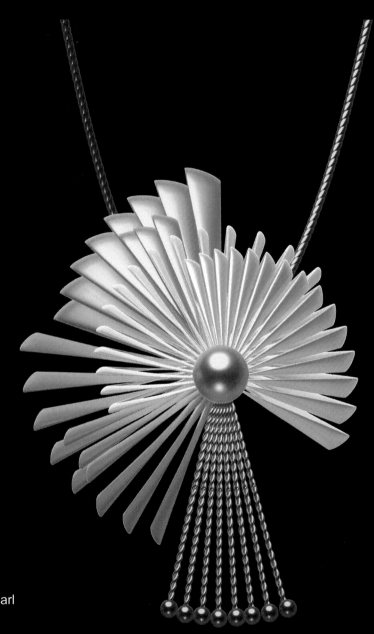

光 芒 四 射
Brightening

白金，黃金，玫瑰金，珍珠
Platinum, Gold, Colour gold, Pearl

194

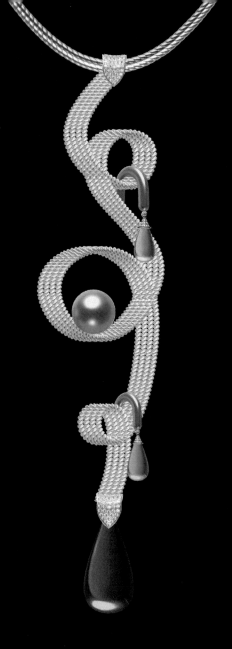

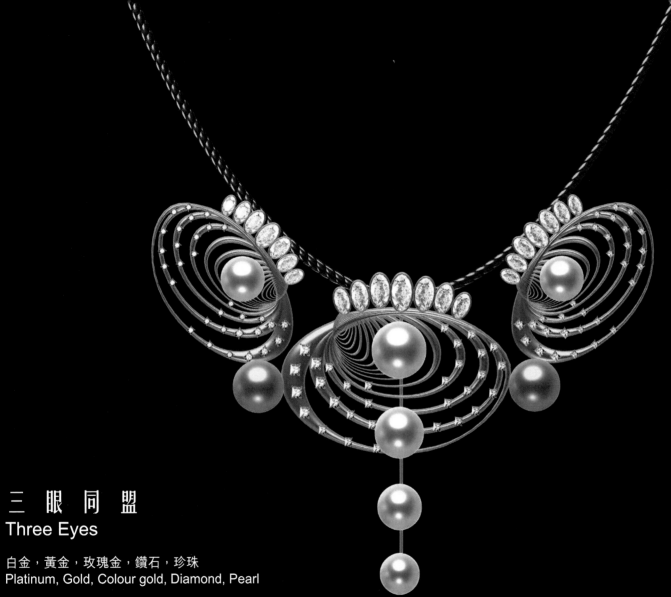

三 眼 同 盟
Three Eyes

白金，黃金，玫瑰金，鑽石，珍珠
Platinum, Gold, Colour gold, Diamond, Pearl

196

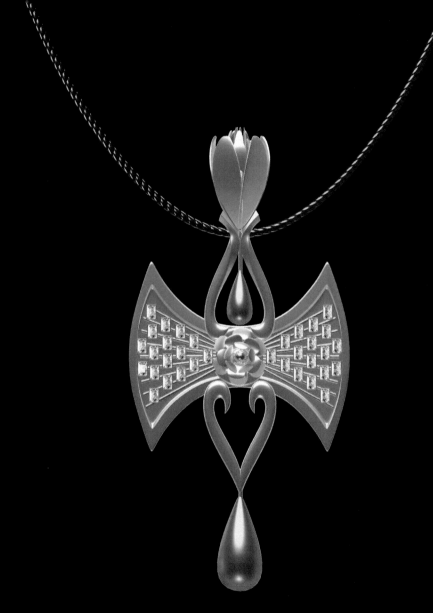

同 心 協 力
Solidarity

白金，黃金，鑽石，水滴珠
Platinum, Gold, Diamond, Gold drip

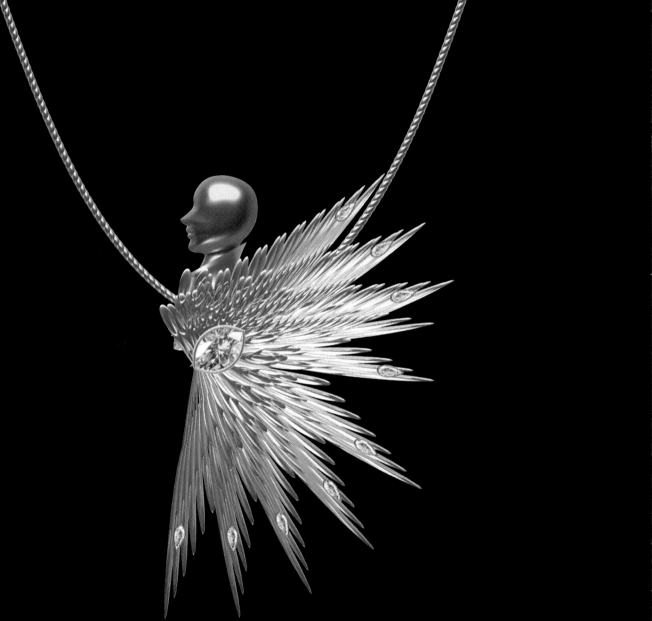

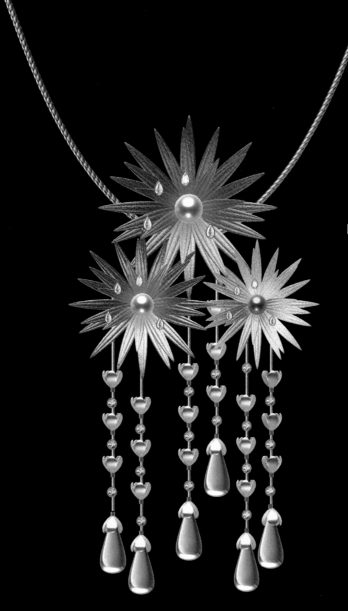

花 花 世 界
Flowers World

白金，黃金，玫瑰金，鑽石，珍珠，白玉髓
Platinum, Gold, Colour gold, Diamond,
Pearl, White chalcedony

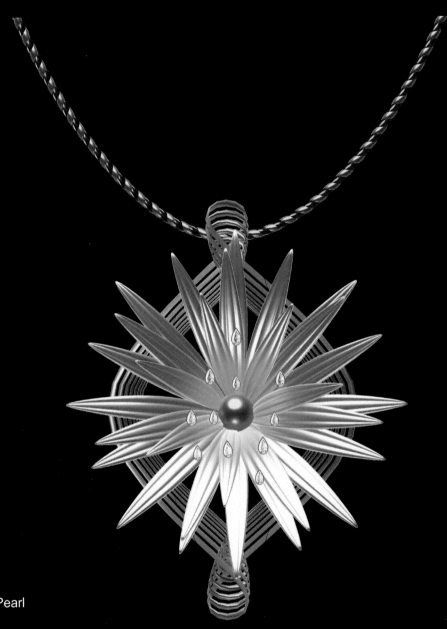

花 藝
Flower Design

白金，黃金，玫瑰金，珍珠
Platinum, Gold, Colour gold, Pearl

200

霧 裏 花
Dazzling Flower

白金，黃金，玫瑰金，鑽石
Platinum, Gold, Colour gold, Diamond

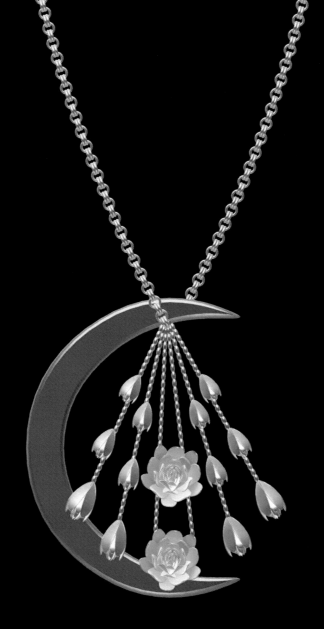

月 下 之 花
Flowers under Moon

白金，黃金
Platinum, Gold

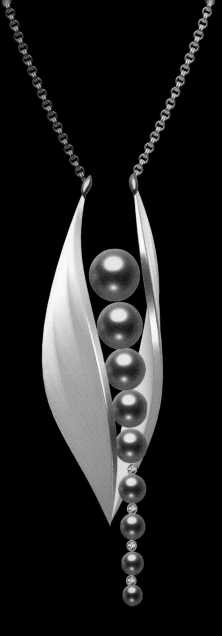

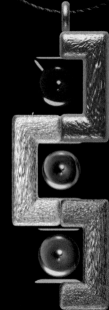

色　玉　扣

ourful Jade

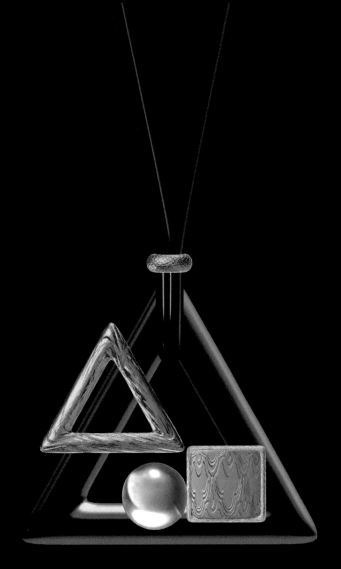

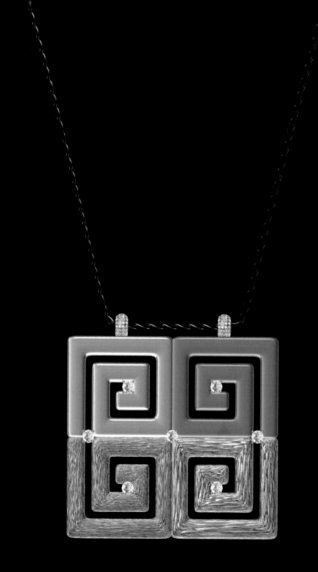

四 方 八 面
Cubics

白金，黃金，翠玉，鑽石
Platinum, Gold, Jade, Diamond

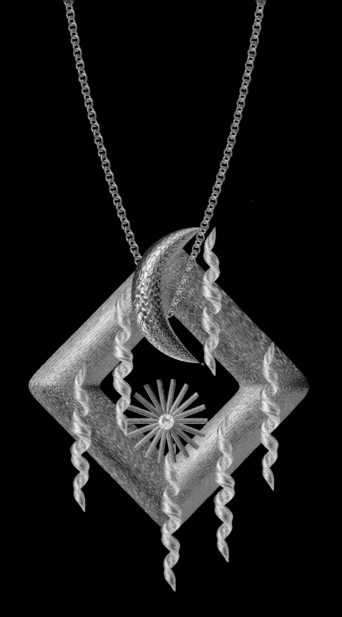

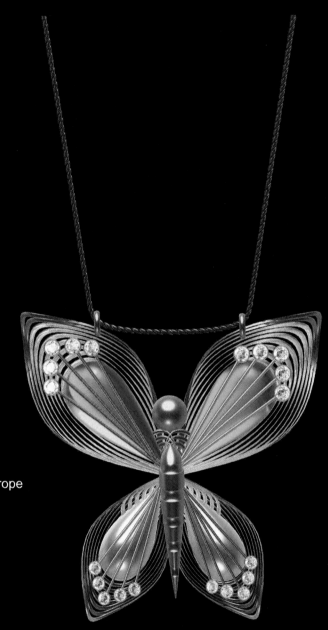

炫 光 蝶
Glare Butterfly

白金，黃金，鑽石，藍白貝母，皮繩
Platinum, Gold, Diamond,
Blue and white mother of pearl, Leather rope

208

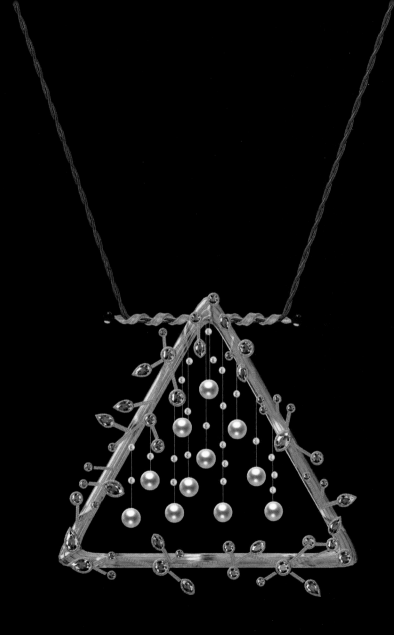

順 與 逆
Time and Tide

黃金，珍珠，藍寶石
Gold, Pearl, Sapphires

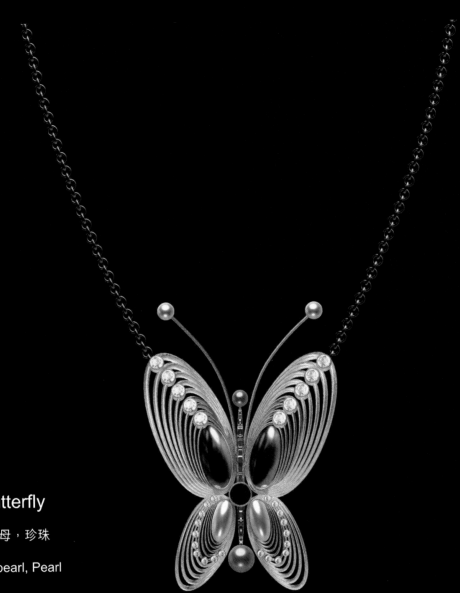

黑 白 蝴 蝶
Black and White Butterfly

白金，黃金，鑽石，黑白貝母，珍珠
Platinum, Gold, Diamond,
Black and white mother of pearl, Pearl

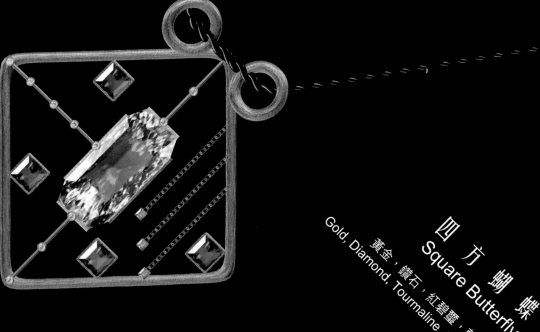

四方蝴蝶
Square Butterfl

黃金，鑽石，紅碧璽，
Gold, Diamond, Tourmaline,

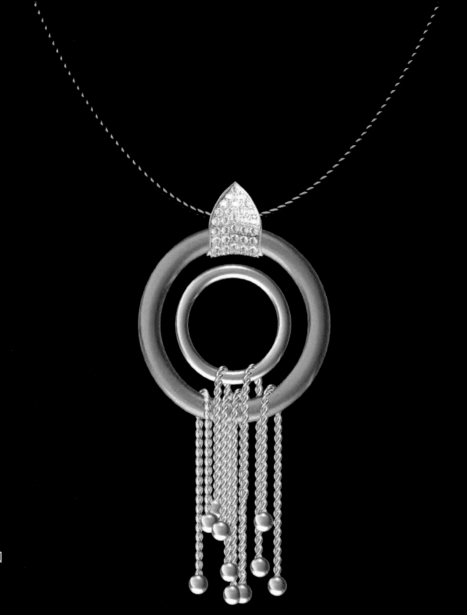

圓 滿 配 搭
Circles

白金，鑽石 , 翠玉扣，白玉扣
Platinum, Diamond,
Green and white jade hook

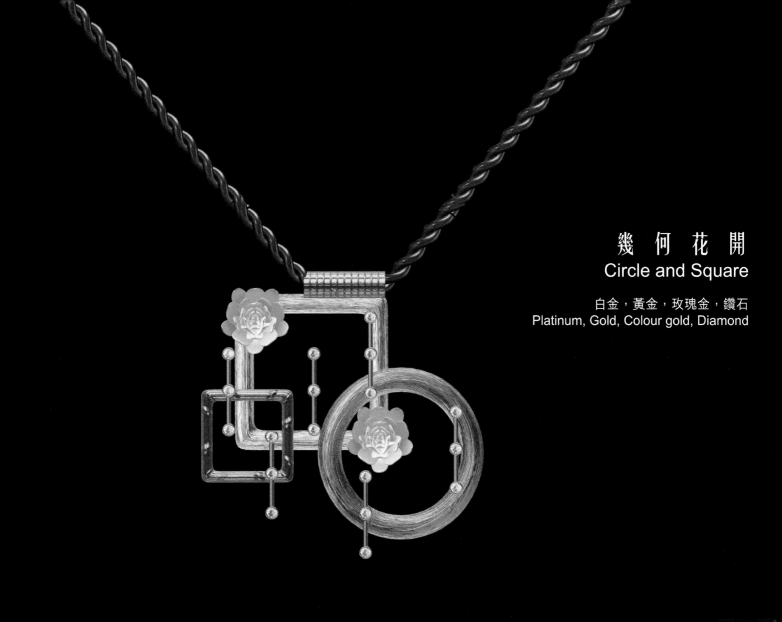

幾 何 花 開
Circle and Square

白金，黃金，玫瑰金，鑽石
Platinum, Gold, Colour gold, Diamond

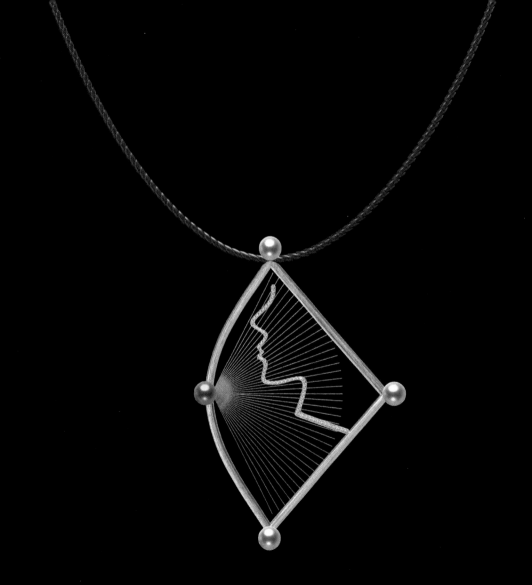

追 光 者
Light Chaser

白金，黃金，珍珠
Platinum, Gold, Pearl

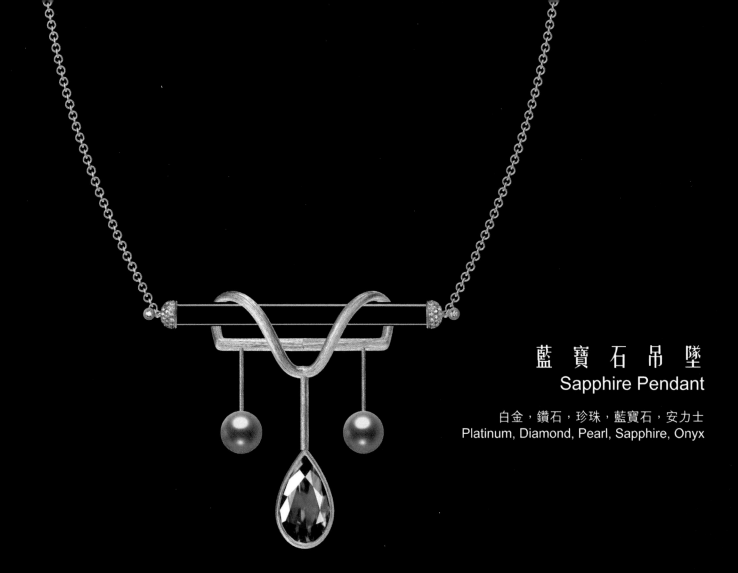

藍寶石吊墜
Sapphire Pendant

白金，鑽石，珍珠，藍寶石，安力士
Platinum, Diamond, Pearl, Sapphire, Onyx

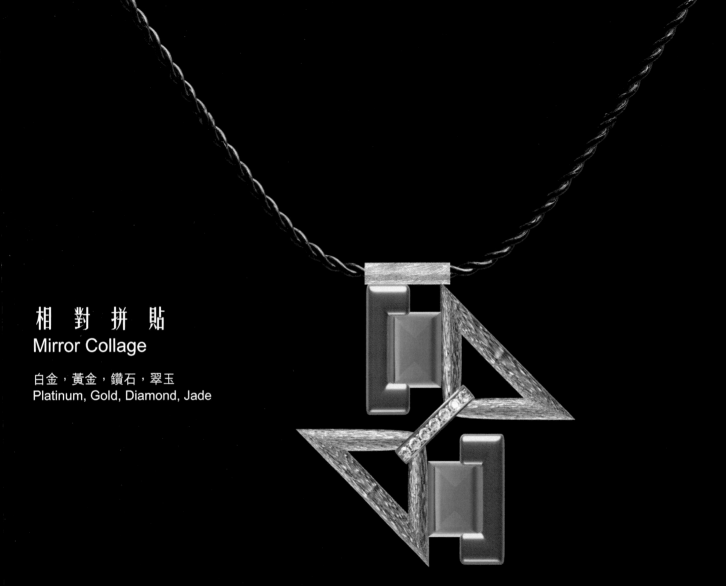

相 對 拼 貼
Mirror Collage

白金，黃金，鑽石，翠玉
Platinum, Gold, Diamond, Jade

黄 玉 吊 墜
Yellow Chalcedony

白金，黃金，鑽石，黃玉髓，安力士
Platinum, Gold, Diamond,
Yellow chalcedony, Onyx

吊 墜 和 襟 針 兩 用
Pendant & Brooch (use in both) 217

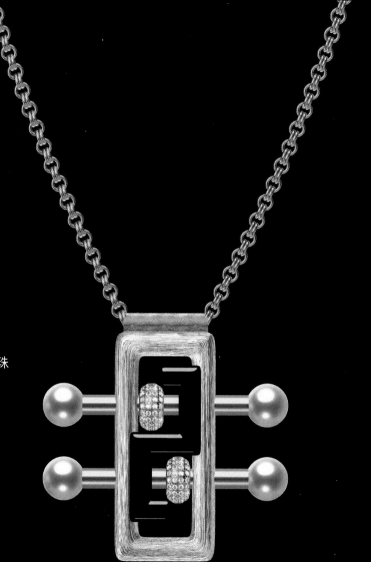

精 打 細 算
Golden Abacus

白金，黃金，玫瑰金，鑽石，安力士，珍珠
Platinum, Gold, Colour gold, Diamond,
Onyx, Pearl

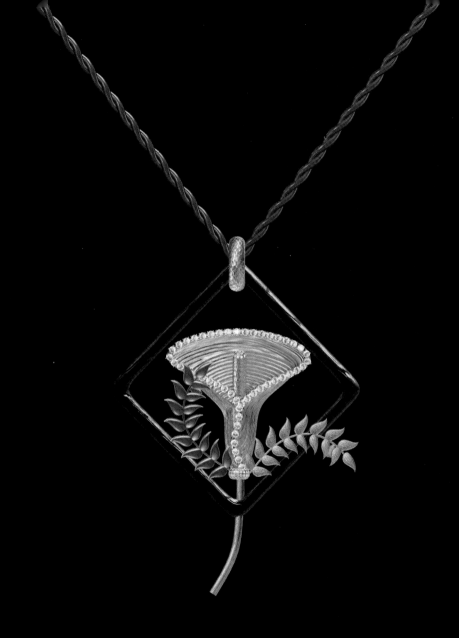

金色馬蹄蘭
Golden Lily

白金，黃金，鑽石，黑金圈
Platinum, Gold, Diamond,
Black gold rings

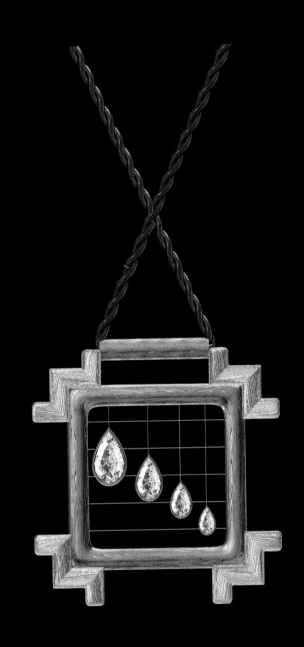

畫 中 雨
Art of Diamond

白金，黃金，鑽石
Platinum, Gold, Diamond

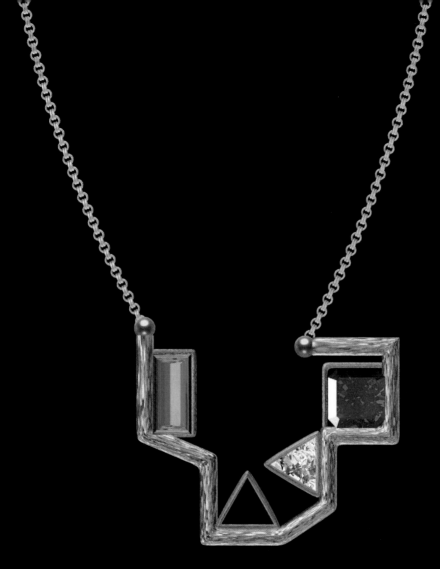

白金，黃金，鑽石，珍珠，
紅寶石，藍寶石，綠寶石
Platinum, Gold, Diamond, Pearl,
Ruby, Sapphire, Emerald

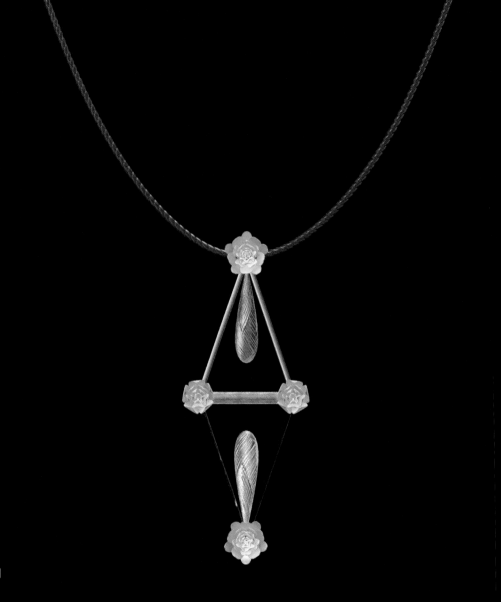

菱 形 設 計
Art of Rhombus

白金，黃金，黑金
Platinum, Gold, Black gold

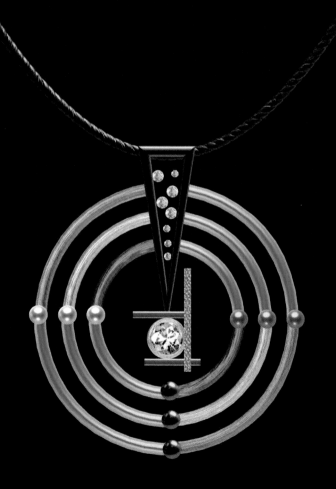

中 心 點

Central Diamond

白金，黃金，玫瑰金，鑽石，
珍珠，安力士，藍色銀線
Platinum, Gold, Colour gold, Diamond,
Pearl, Onyx, Blue silver wires

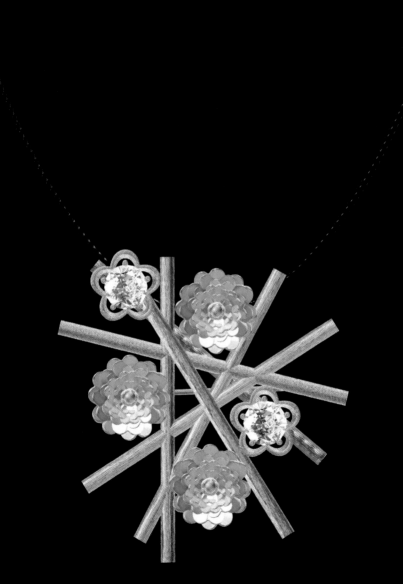

擦 出 火 花
Flaming

白金，黃金，鑽石，珍珠
Platinum, Gold, Diamond, Pearl

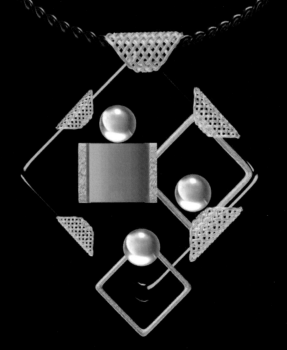

一 點 綠
Green Dot

白金，黃金，翠玉，白玉珠，安力士
Platinum, Gold, Jade,
Green and white jade, Onyx

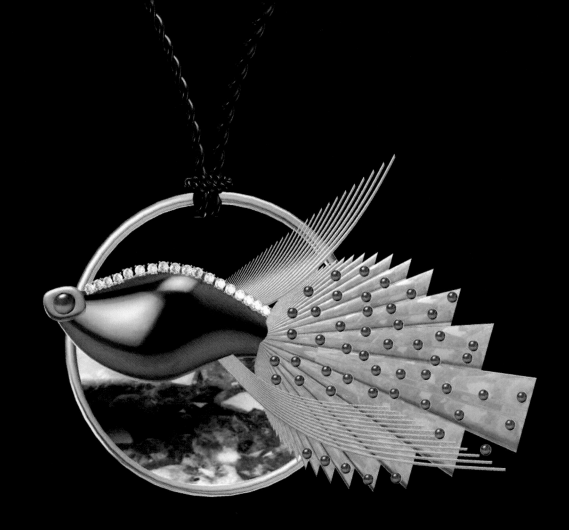

如 魚 得 水
Vivid Fish

黃金，白金，鑽石，珍珠，貝母，藍銀片
Gold, Platinum, Diamond, Pearl,
Mother of pearl, Blue silver

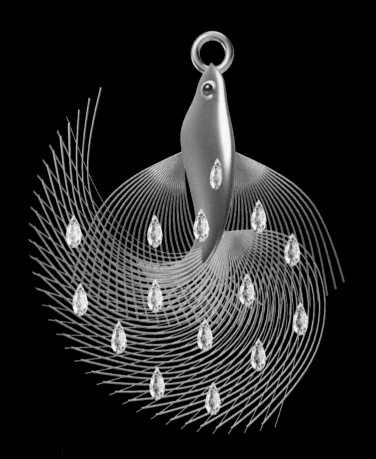

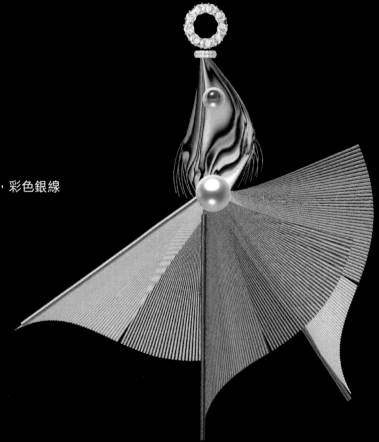

魚　美　人
Dancing Fish

白金，黃金，鑽石，珍珠，熒光片，彩色銀線
Platinum, Gold, Diamond, Pearl,
Fluorescent film, Colour wires

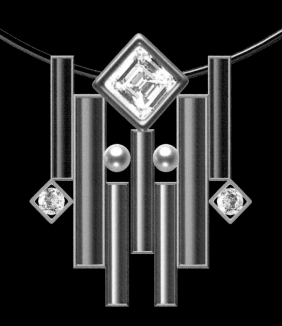

瑰 麗
Display of Colours

黃金，鑽石，珍珠，彩色鋁片
Gold, Diamond, Pearl, Colour aluminium

戒指

RING

外方內圓
Ring in the Box

白金，黃金，鑽石，藍色琺瑯
Platinum, Gold, Diamond, Blue enamel

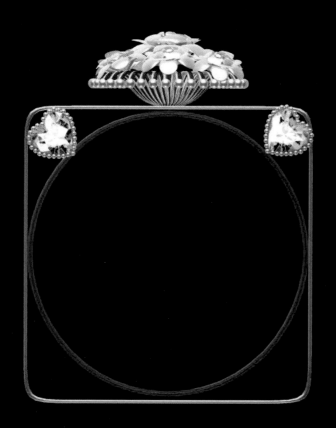

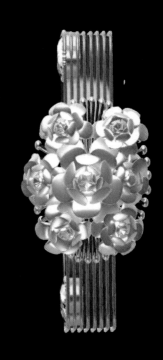

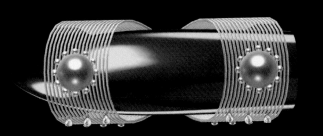

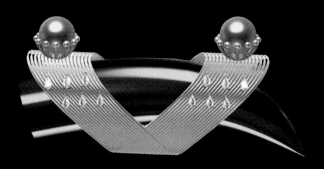

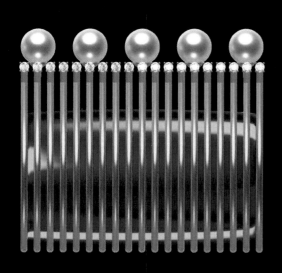

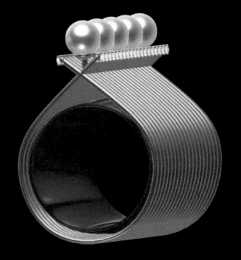

珍 珠 戒 指
Pearl Ring

白金，黃金，鑽石，珍珠，藍色琺瑯
Platinum, Gold, Diamond, Pearl, Blue enamel

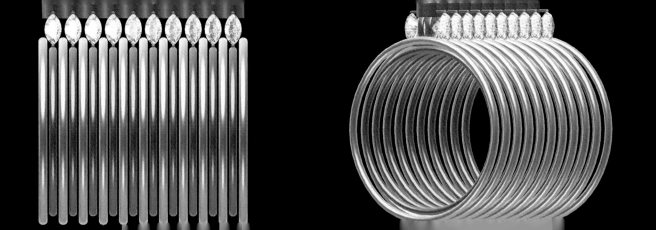

藍線戒指
Packing Ring

白金，鑽石，藍白銀線
Platinum, Diamond, Blue and white silver wires

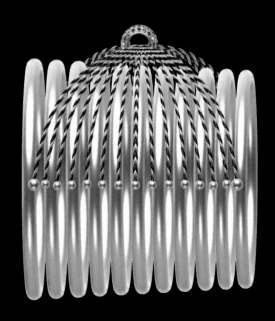
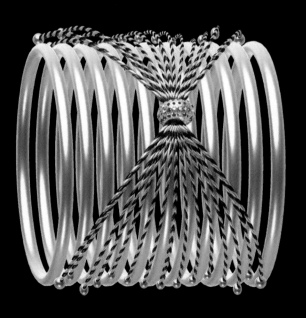

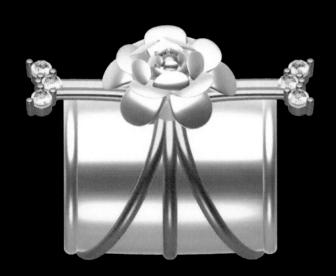

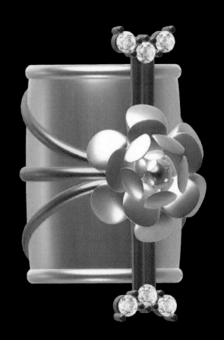

花　架
Jardiniere

白金，黃金，玫瑰金，鑽石
Platinum, Gold, Colour gold, Diamond

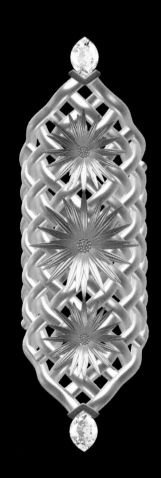

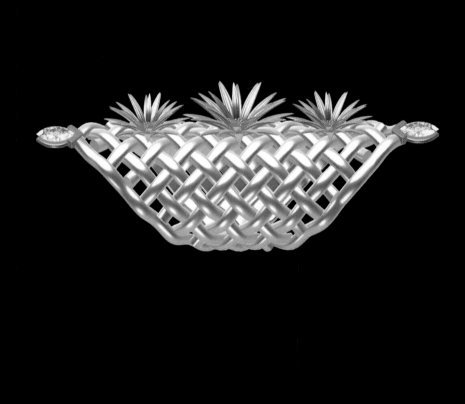

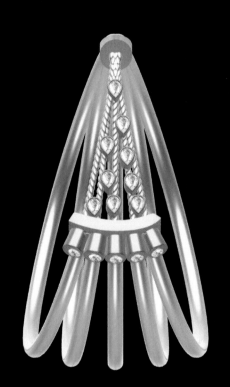

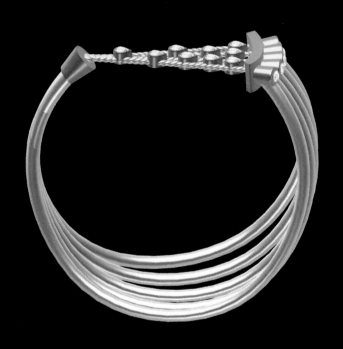

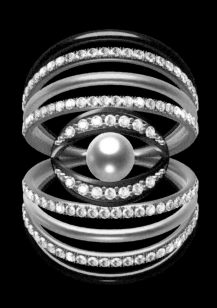

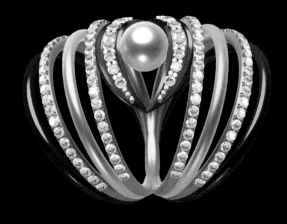

眼 中 世 界
In Your Eyes

鑽石，珍珠，多色銀線
Diamond, Pearl, Colour silver wires

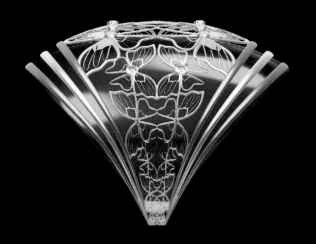
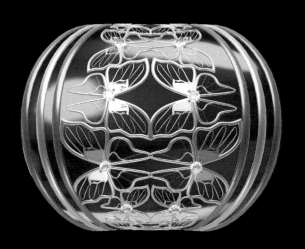

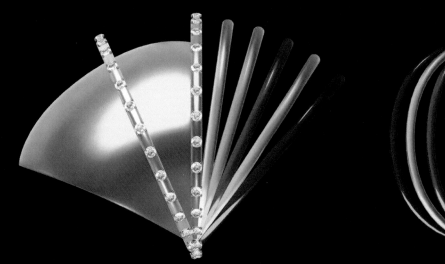

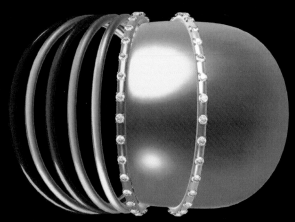

彩 半 球
Colourful Hemisphere

白金，黃金，鑽石，多色銀線
Platinum, Gold, Diamond, Colour silver

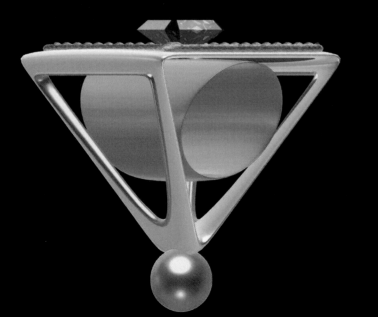
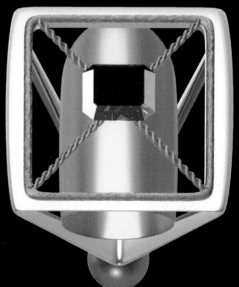

掌 上 明 珠
Pearl on the Palm

白金，黃金，藍寶石，珍珠
Platinum, Gold, Sapphire, Pearl

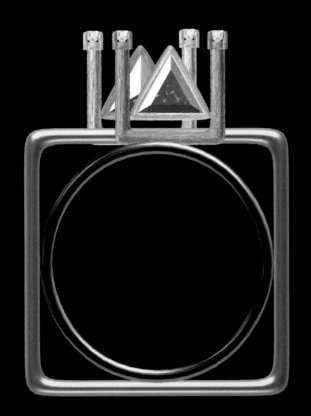
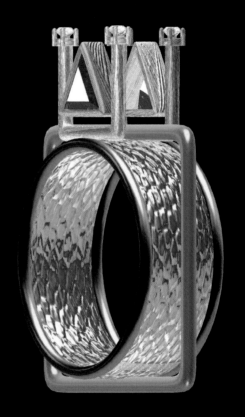

指 上 寶 座
Ring of Throne

白金，黃金，黑金，鑽石，藍寶石
Platinum, Gold, Black gold,
Diamond, Sapphire

記憶體

USB

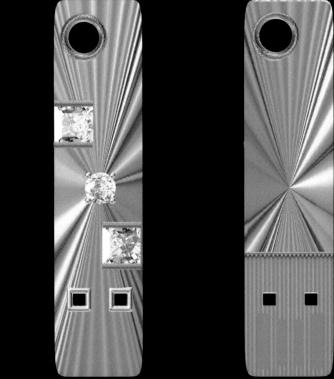

來 日 方 長

白金，黃金，黑金，藍寶石，記憶體
Platinum, Gold, Black gold,
Sapphire, USB

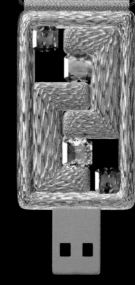

拼　圖
Puzzle USB

白金，黃金，紅碧璽，藍寶石，記憶體
Platinum, Gold, Tourmaline, Sapphire, USB

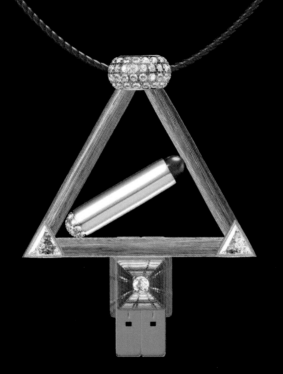

妙 筆 生 花
USB with Touch Screen Pen

白金，黃金，黑金，鑽石，
黑皮繩，記憶體，觸控筆
Platinum, Gold, Black gold, Diamond,
Black leather rope, USB,
Touch screen pen

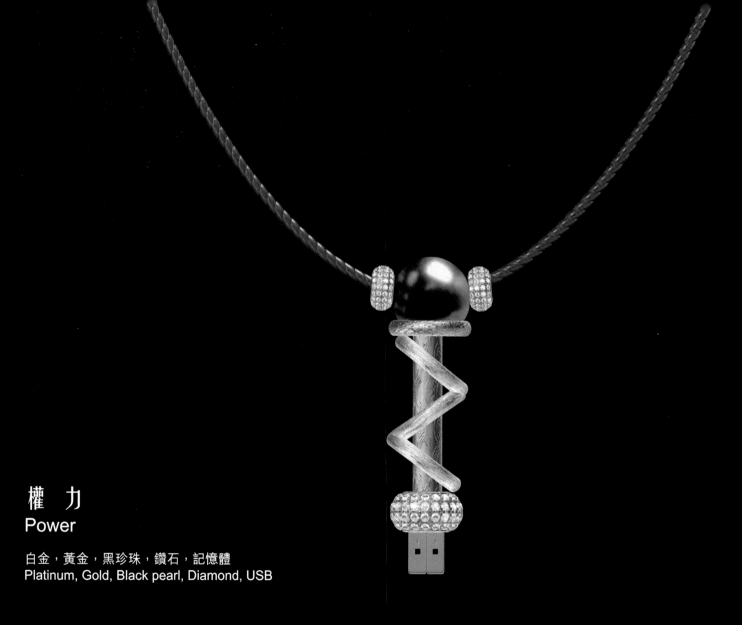

權 力
Power

白金，黃金，黑珍珠，鑽石，記憶體
Platinum, Gold, Black pearl, Diamond, USB

拍　檔
Partner

白金，黃金，珍珠，翠玉，記憶體
Platinum, Gold, Pearl, Jade, USB

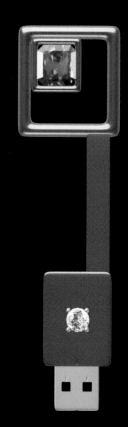

金 鎖 匙
Golden Key

黃金，鑽石，藍寶石，記憶體
Gold, Diamond, Sapphire, USB

套裝
SET

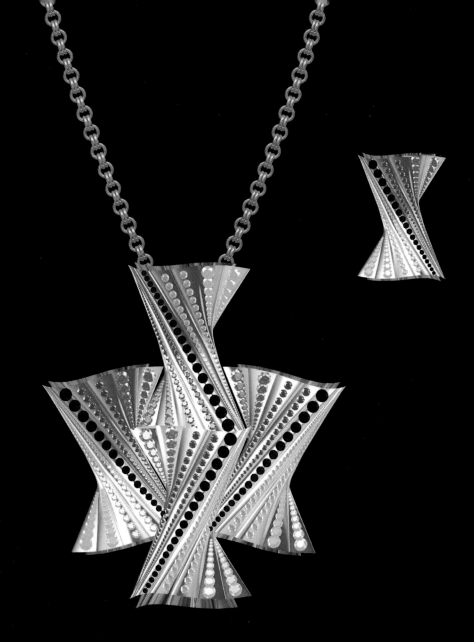

不 規 則 圖 案
Random Pattern

黃金，彩鑽
Gold, Colour stones

www.cosmosbooks.com.hk

書　名	炫繪
作　者	蔡昭儷
責任編輯	吳惠芬
美術編輯	郭志民
出　版	天地圖書有限公司
	香港黃竹坑道46號新興工業大廈11樓（總寫字樓）
	電話：2528 3671　　傳真：2865 2609
	香港灣仔莊士敦道30號地庫（門市部）
	電話：2865 0708　　傳真：2861 1541
印　刷	亨泰印刷有限公司
	香港柴灣利眾街德景工業大廈10字樓
	電話：2896 3687　　傳真：2558 1902
發　行	聯合新零售（香港）有限公司
	香港新界荃灣德士古道220-248號荃灣工業中心16樓
	電話：2150 2100　　傳真：2407 3062
初版日期	2024年5月 / 初版・香港